IMAGES
of America
THE OXFORD HILLS
GREENWOOD, NORWAY, OXFORD, PARIS, WEST PARIS AND WOODSTOCK

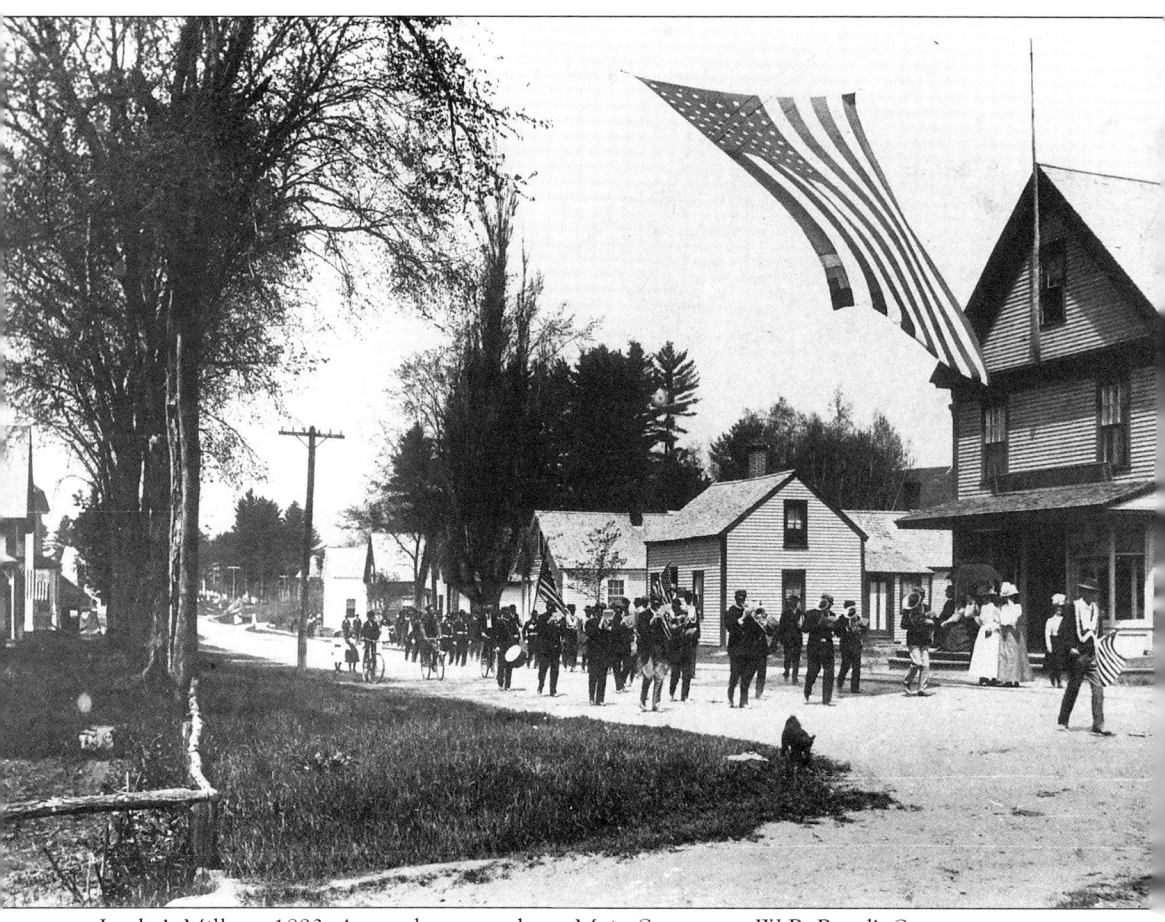
Locke's Mills, c. 1893. A parade moves down Main Street past W.B. Rand's Store.

IMAGES of America
THE OXFORD HILLS
GREENWOOD, NORWAY, OXFORD, PARIS, WEST PARIS AND WOODSTOCK

Compiled by
Diane and Jack Barnes

Copyright © 2004 by Diane and Jack Barnes
ISBN 0-7385-3674-1

First published 1995
Revised Edition 2004

Published by Arcadia Publishing,
Charleston SC, Chicago IL, Portsmouth NH, San Francisco CA

Printed in Great Britain

Library of Congress Catalog Card Number: 2004108614

For all general information, contact Arcadia Publishing:
Telephone 843-853-2070
Fax 843-853-0044
E-mail sales@arcadiapublishing.com
For customer service and orders:
Toll-free 1-888-313-2665

Visit us on the Internet at www.arcadiapublishing.com

On the cover: Locke's Mills, c. 1905. Woodsum's Camp on Round Pond was often photographed by Guy Coffin and Nettie Cummings Maxim.

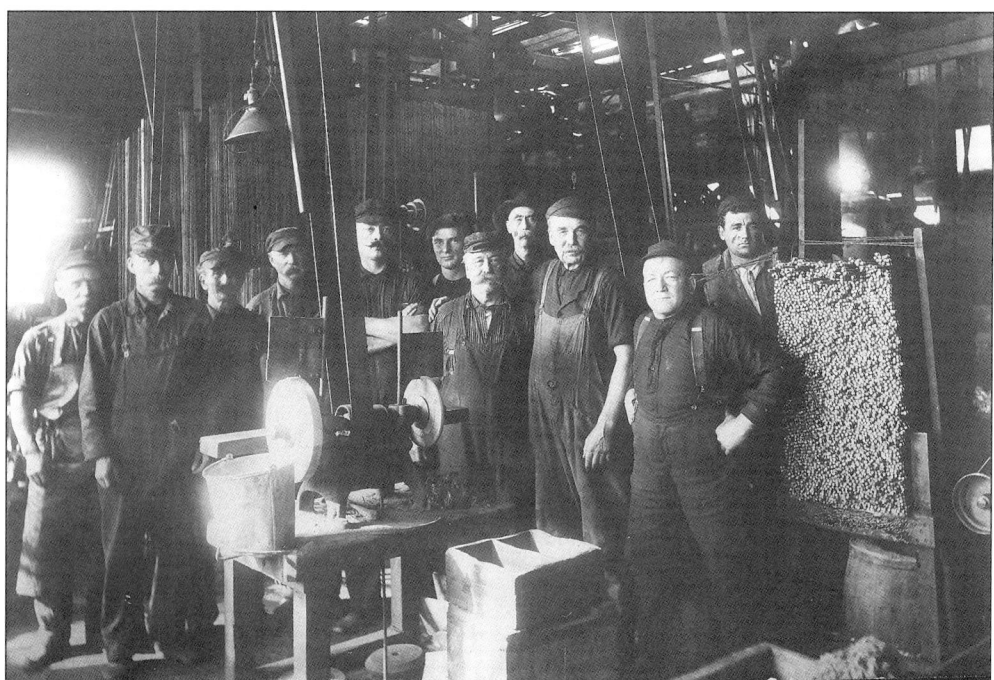

Paris, c. 1906. An interior view of the toy factory of the Mason Manufacturing Company.

Contents

Acknowledgments 6

Introduction 7

1. Greenwood 9
2. Norway 33
3. Oxford 59
4. Paris 71
5. West Paris 97
6. Woodstock 117

Acknowledgments

The creation of this book was greatly facilitated by the keen awareness of the past and the desire to record and preserve it that exists in the six towns of the Oxford Hills region.

We should like to thank the Greenwood Historical Society, Norway Historical Society, Norway Memorial Library, Oxford Historical Society, Paris Cape Historical Society, and West Paris Historical Society for the generous sharing of their photographs, books, and other memorabilia. We should also like to thank Lona Bedard, Pete Chase, Ben B. Conant, Richard Fraser, Roberta Gordon, Sidney Gordon, Milton Inman, Reverend Don L. McAllister, Nancy Marcotte, Bernice Merrill, Clarence Merrill, Blaine Mills, Margaret Mills, Jane Perham, Basil Seguin, and Jane Sumner for the generous sharing of their photographs, books, materials, and vast quantities of helpful information. It is only through their help and cooperation that this project has come to fruition.

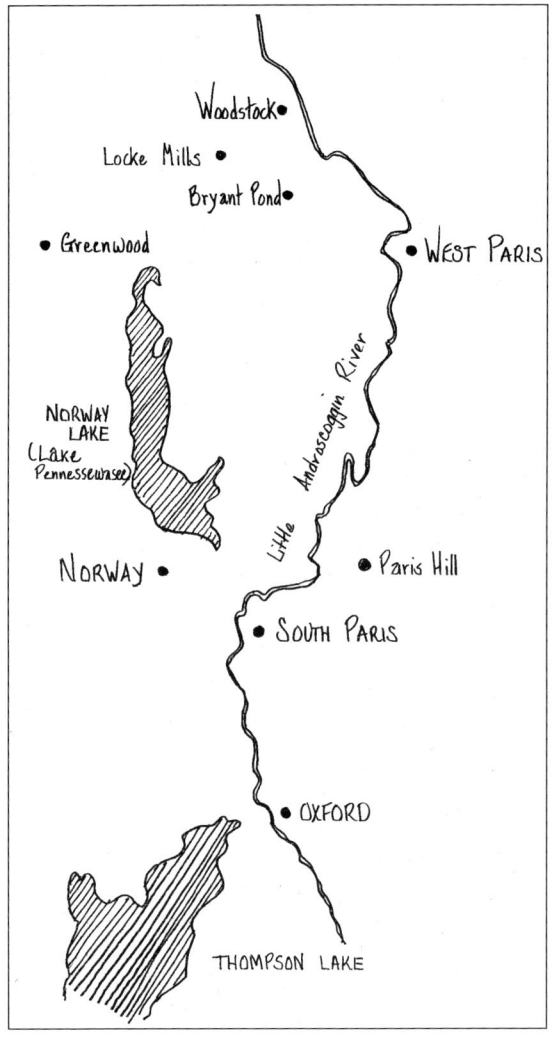

The Oxford Hills. (Nancy Marcotte)

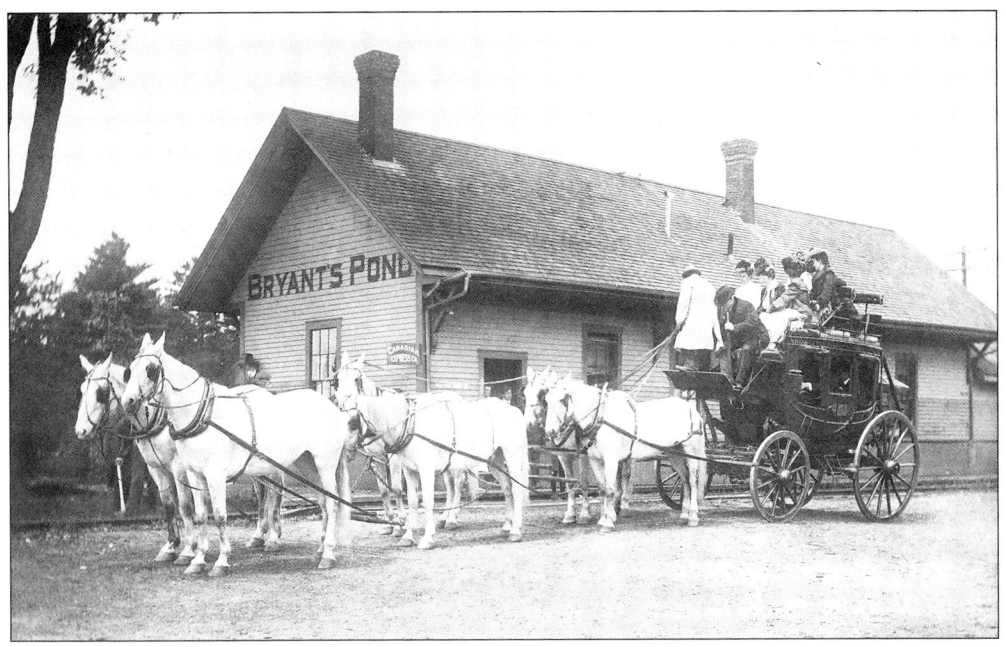
Bryant's Pond Stage, c. 1910. Driven by Joseph Tuttle, the stage is about to depart from the Bryant's Pond Railroad Station for its regular run to Andover and Rumford's Falls.

Introduction

The Oxford Hills, as we have chosen to define it after consulting with a number of distinguished local historians, begins with the town of Oxford, bounding Cumberland County, and extends north roughly along the Little Androscoggin River to include Paris, Norway, West Paris, Woodstock, and Greenwood.

The hinterland of Maine, including the Oxford Hills, was relatively slow to develop. It was not until after the French and Indian War (1763) that settlers felt secure enough from Indian attacks to venture inland to any extent. Around 1779 the first trees were cut and a few log cabins built in what are today the towns of Oxford and Paris. None of the six towns in the Oxford Hills were incorporated until after the Revolutionary War, and only Norway and Paris were incorporated when the area was still part of Cumberland County. The early settlers, including many veterans of the Revolutionary War, began clearing land on the sides and summits of hills such as Paris Hill, because of the prevailing belief at the time that high ground made tilling easier.

In the early stages of agriculture, those who settled on the postage stamp-sized hill farms were primarily subsistence farmers. But soon vast areas of woodlands were cleared, and lowland farms began to prosper. In almost every instance these farms were diversified and were referred to as general farms.

Following closely in the wake of the early settlers came blacksmiths, millers, loggers, and cabinetmakers. But more than anything else, it was the sawmills that really set the communities of the Oxford Hills in motion. Today, wood products remain the backbone of the economy throughout the region.

Getting these products to outside markets was not an easy task, and without a doubt, the pivotal factor in the area's economic and social development was the completion of the Grand Trunk Railroad. Running roughly parallel to the Little Androscoggin River, the railroad linked the Oxford Hills to the deep water port of Portland, the hub city of Boston, and north to Canada, which gave the area's industries a tremendous boost.

As transportation improved, another industry developed in the Oxford Hills: tourism. More and more tourists and sportsmen began to frequent the area, drawn by the ineffable natural beauty of the hills. Recreation was also popular on such bodies of water as Thompson Lake in Oxford, Lake Pennesseewassee in Norway, Christopher Lake in Woodstock, and North and South Pond in Greenwood.

Many changes have transpired since the sound of the first axe resounded through the valley of the Little Androscoggin; unfortunately, the camera was invented over half a century after the area was first settled, so we have little visual documentation from that early period. Soon after the camera was invented, however, a number of professional and semi-professional photographers began capturing moments of life in the Oxford Hills. Thanks largely to the well-organized historical societies (memory houses) and a number of very helpful and dedicated individuals, we have been able to assemble a gallery of vignettes chronicling more than half a century of rural and small town economic development and social activities. We hope that this will render it possible for many readers to establish an intimate sense of connectedness with the past of the Oxford Hills.

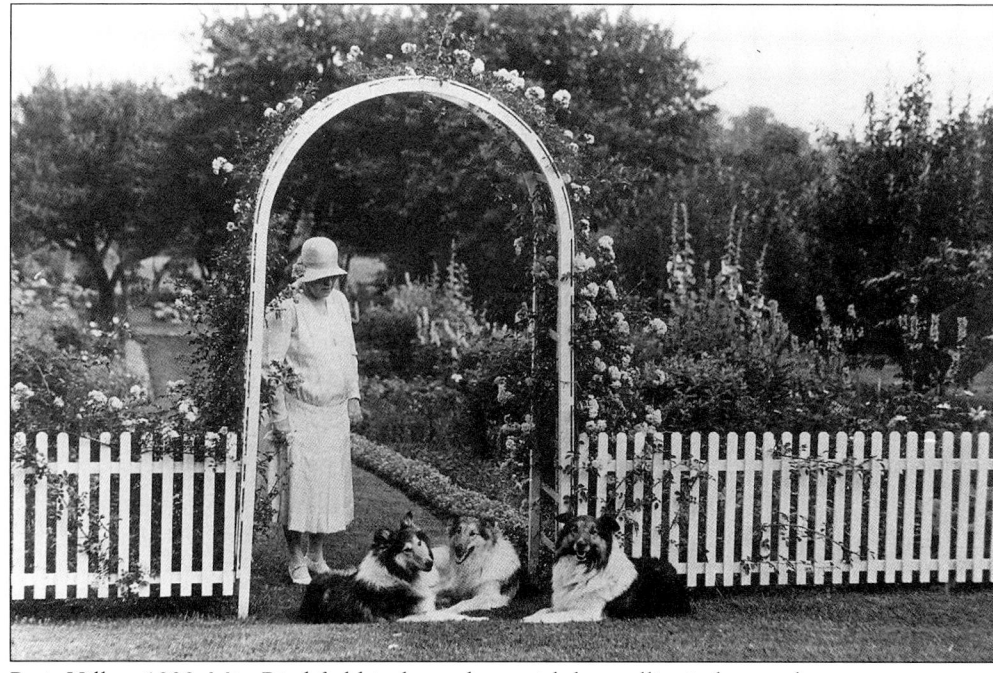

Paris Hill, c. 1930. Miss Birchfield is shown here with her collies in her garden.

One
Greenwood

First Settled: 1802
Incorporated: February 1816
Population in 1990: 689
Area: 43.27 square miles
Principal Settlement: Locke's Mills

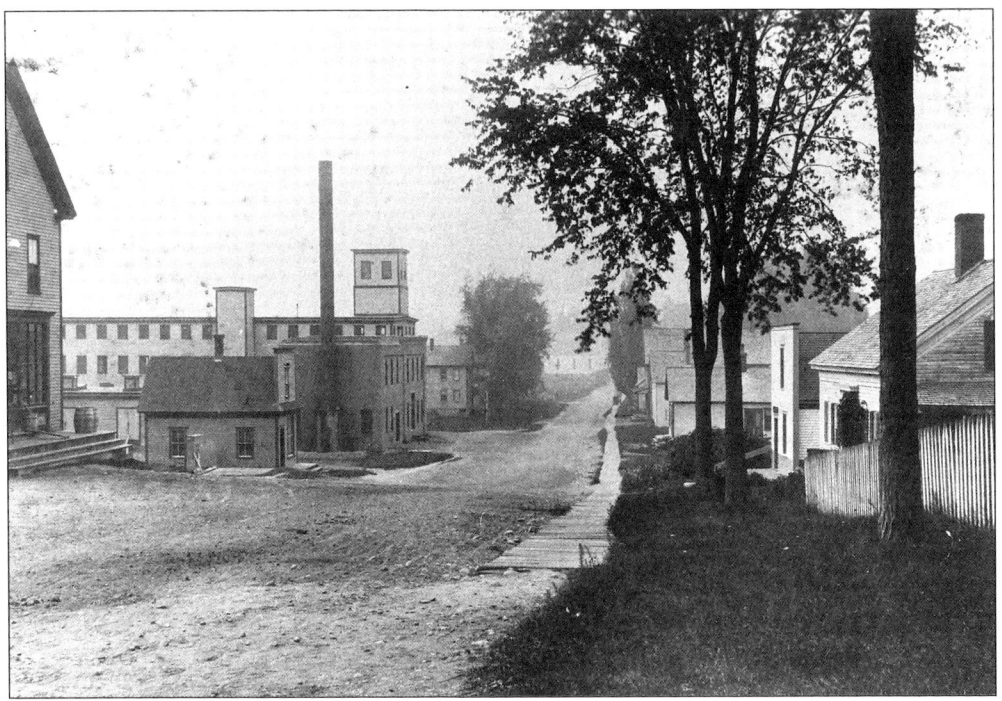

Looking west on Main Street in Locke's Mills, c. 1892. To the left are the Tebbets Manufacturing Company office, the boiler and mill, the Old Yellow House (company rent), and the church, while to the right can be seen the Tebbets House, the post office, the barber shop, a company house, and the company store.

Samuel B. Locke II, mill proprietor and postmaster (from 1840 to 1849). In 1839 he moved to Locke's Mills from Buxton with his family and took over operation of the mills from his father, who resided at a farm in Bethel. Samuel sold out to Moses Houghton around 1857 and moved to West Paris. Postmasters were political appointments in the nineteenth century. It is claimed locally that there were two post offices in Locke's Mills—a Democrat one and a Republican one, located on opposite sides of Main Street. As political power shifted at the national level, the official post office moved back and forth across Main Street.

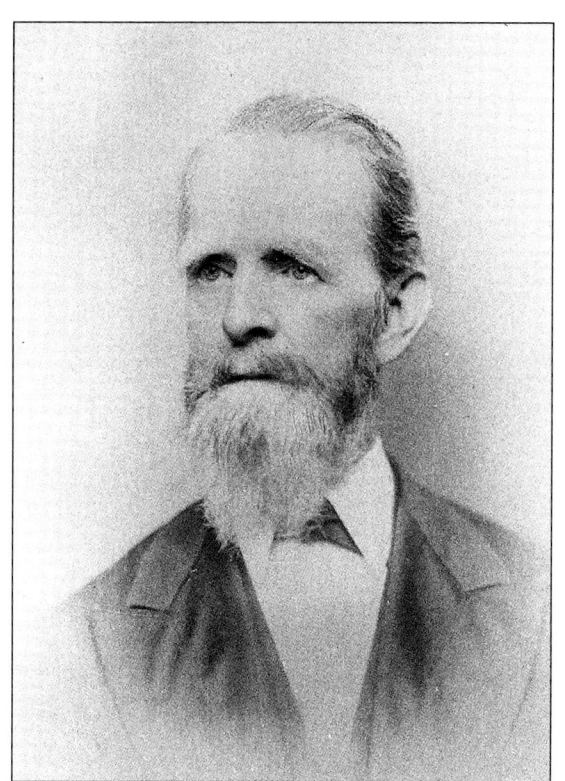

Sawmill at Twitchell Pond, c. 1890–1900. This sawmill was built by Samuel B. Locke in 1850. The carriage is going south toward Greenwood City.

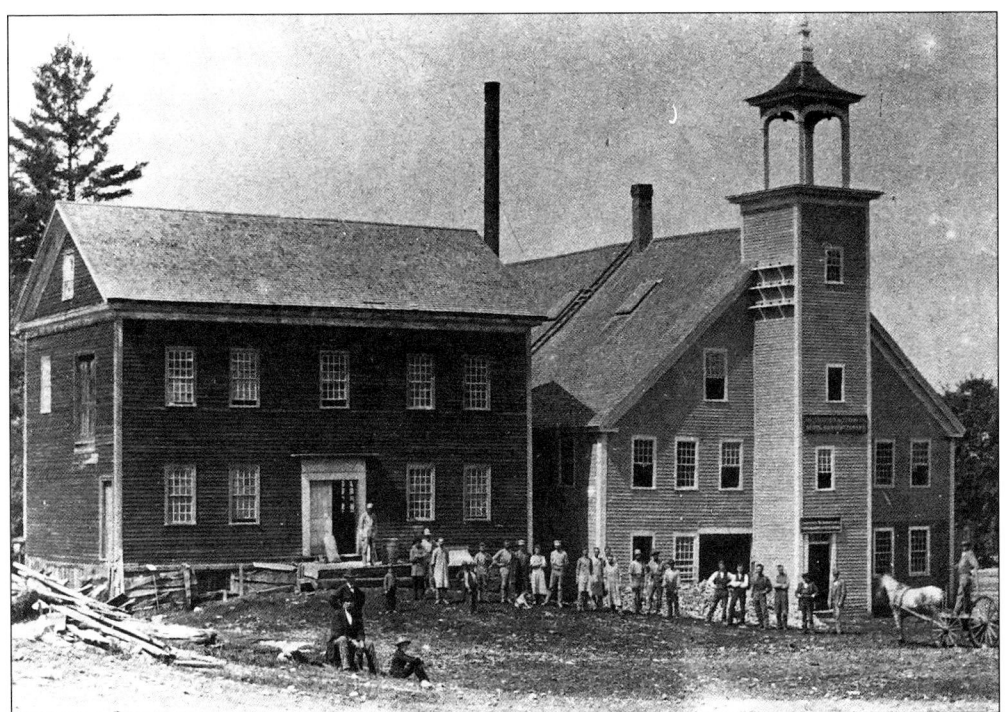

Dearborn & Tebbets Grist Mill and Spool Mill, c. 1871–78. Samuel E. Locke, Jr., built the grist mill soon after the mill fire of 1842. In 1845 he built the factory building that later became the spool mill. In the fall of 1879 a fire started in the grist mill; it burned both buildings, the first stable, and A.G. Woodsum's Store.

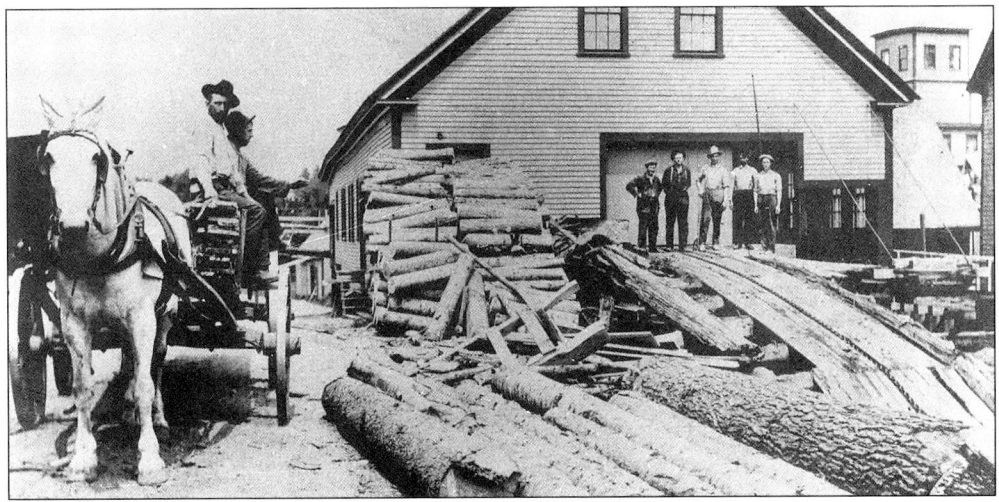

The Long Lumber Mill, c. 1900–10. This crew was photographed while logs were being pulled up from the Mill Pond. A team of horses can be seen to the left.

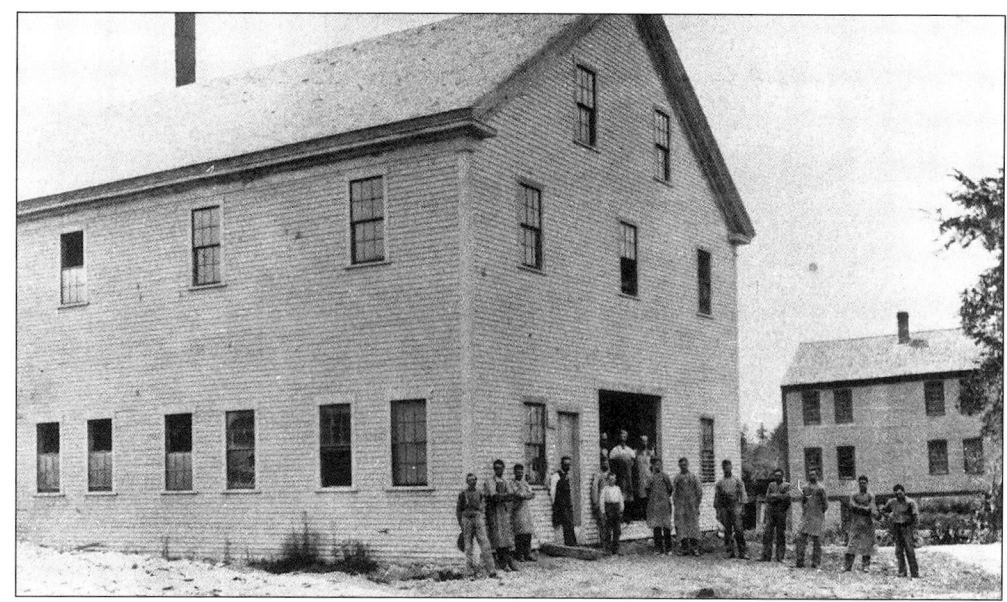

A view from Tebbets Manufacturing Company, c. 1880–90, looking west. The first spool mill burned in 1879. J.G. Tebbets built this spool mill in 1880, but it never appeared on the 1880 map. This mill eventually burned in the mill fire of February 8, 1891. The house in the background is the Old Yellow House, which was thought to have been a company rent. The company tore it down around 1968 to make a parking lot.

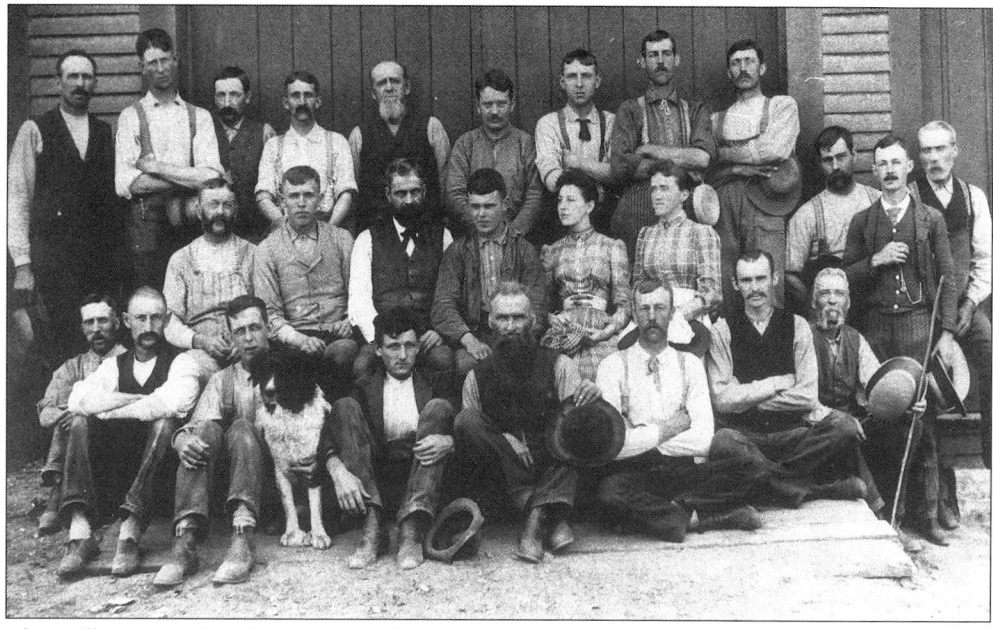

The mill crew at the Tebbets Manufacturing Company, c. 1880–90. Shown are, from left to right: (front row) Nelson Swift, Oscar Brown, Stephen Libby, Ed Herrick, Owen Seeley, William H. "Gramp" Crockett, Harry Seeley, and Abner Herrick; (middle row) Rufus Young, Mort Abbott, George Cole, Arthur Tetu, Carrie Ayer, Ella Sanborn, James Crooker, Moses Young, and Moses Knight; (back row) Lewis J. Bryant, John Bean, Roscoe Cummings, Charles Stowell, Horace Berry, Columbus Kimball, Westley Kimball, Jonathan Crockett, and Azel Bryant.

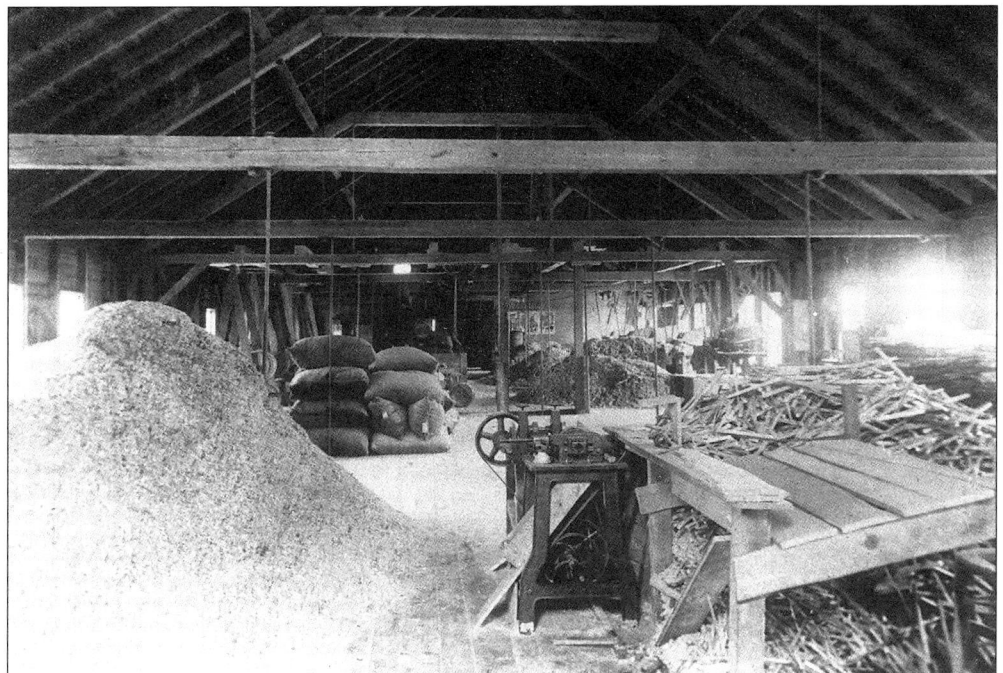

The Tebbets Manufacturing Company, c. 1880–90. This is the second story in the spool mill, built in 1880. One can see why it burned in 1891. Shavings, edgings, bags of spools, and machinery can be seen.

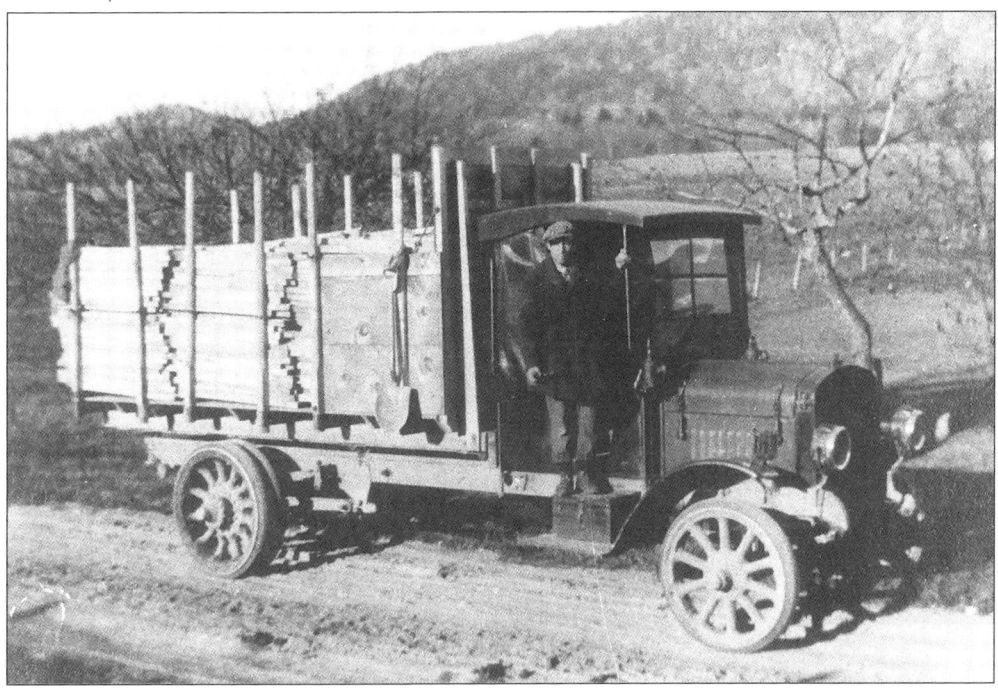

The first company truck used by the E.L. Tebbets Spool Company, c. 1918–19. Cliff McAllister is shown here on the road to Andover with the company's first truck, a Kessel Chain Drive with gas lights.

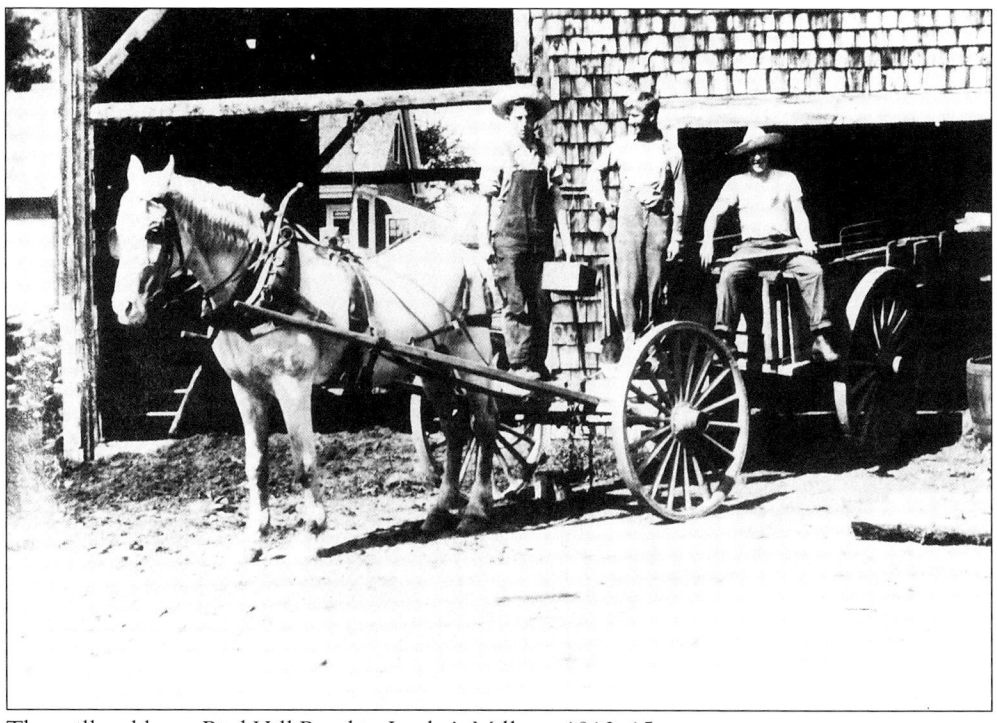

The Tebbets Company Store, c. 1870–80. Built sometime after 1866, a second story was added around 1875–80. It was torn down by the company in 1958.

The mill stable on Bird Hill Road in Locke's Mills, c. 1910–15.

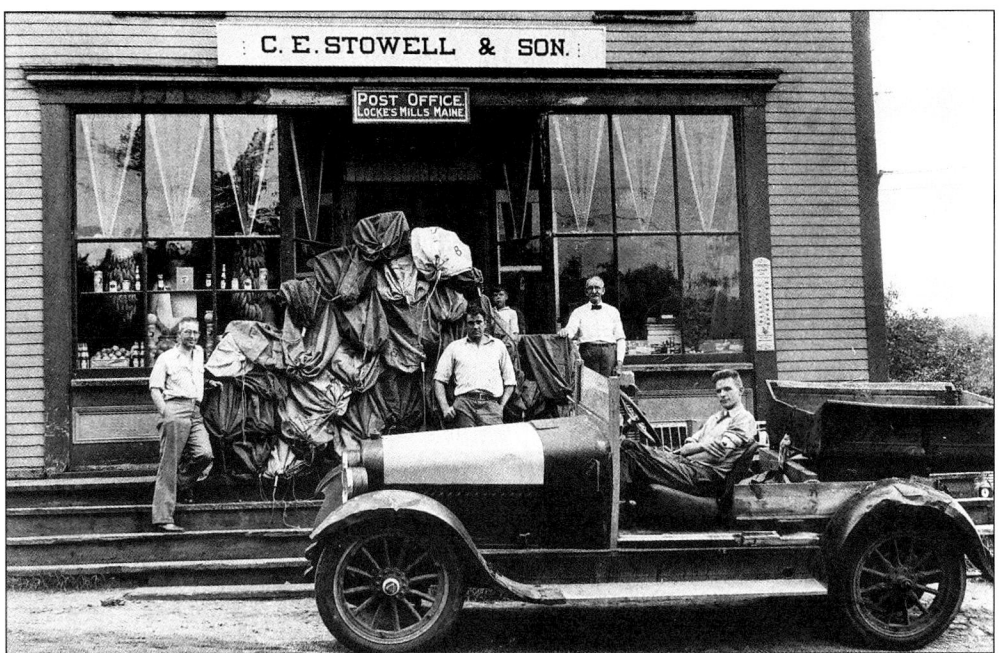

In this c. 1932 photograph, a mountain of bags filled with wooden Popeye toys has just been unloaded from the Tebbets company truck (a mid-1920s Hudson) at the Charles P. Stowell & Son Store and Post Office. From left to right are Arthur Stowell, Joe Vetquosky, an unidentified boy, Charles Stowell, and Merle Lurvey (in the mill truck).

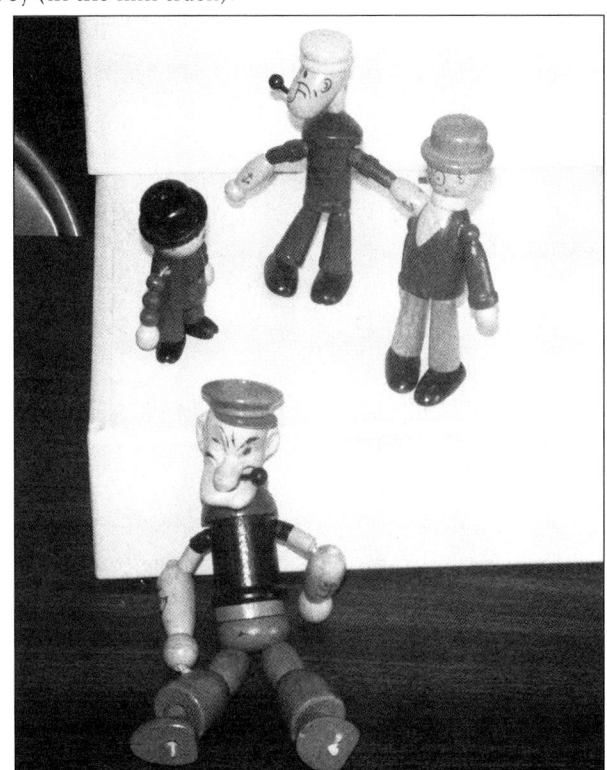

Several Popeye toys manufactured at the Tebbets Mill between the 1920s and early 1940s.

15

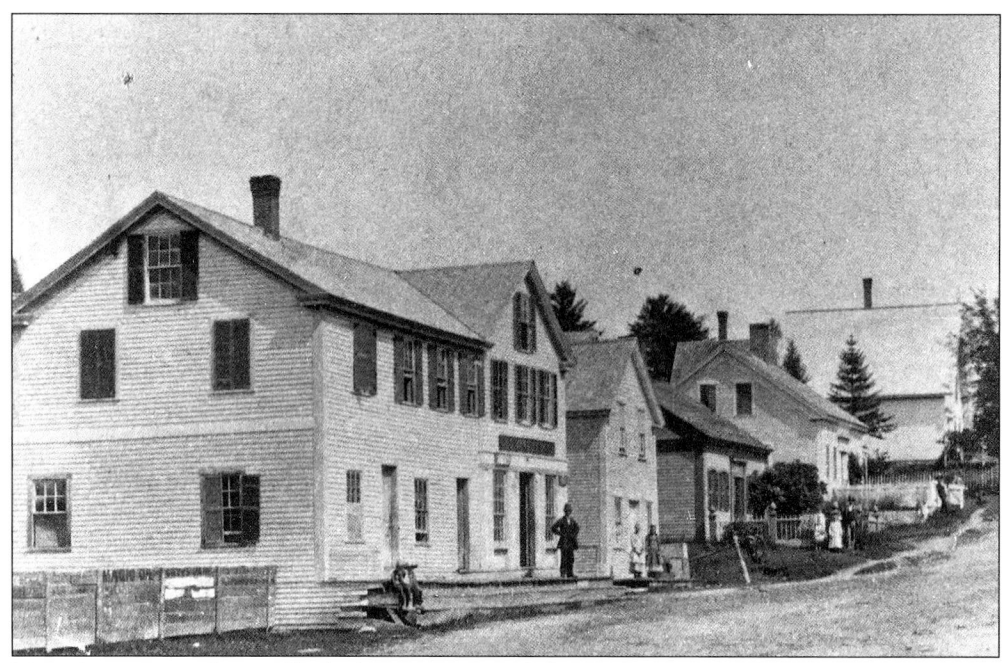

Main Street in Locke's Mills, looking east. From left to right are Aranda Tinkham's Store and Post Office, an unoccupied building owned by Tinkham, and the homes of Mrs. Daniel, A.J. Cole, and Aranda Tinkham.

This c. 1890–1900 photograph is of Aranda G. Tinkham, trader and postmaster.

This is a view of W.B. Rand's Store on Main Street before it was made over to a double tenant house (c. 1900). It was Currier Hall before it became a store in 1889.

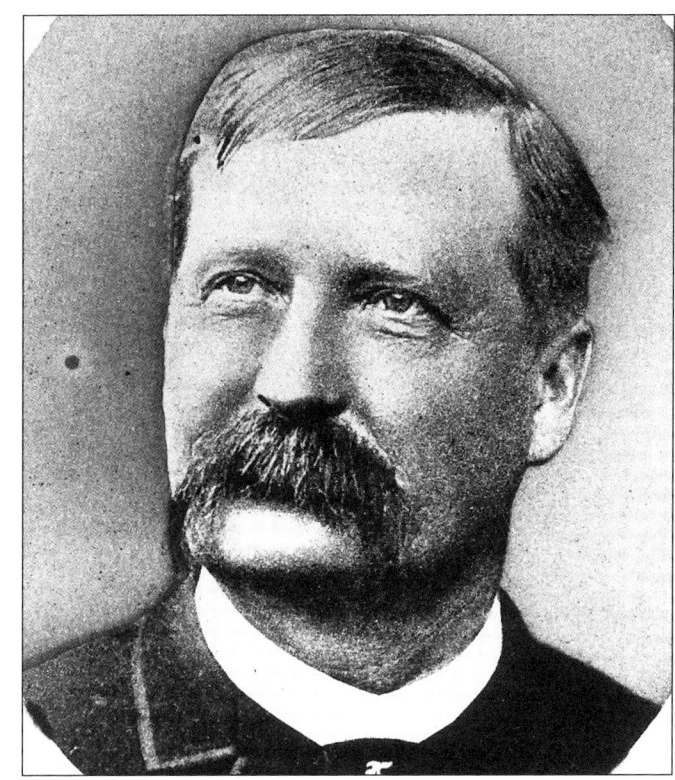

Eben E. Rand was born on April 27, 1841, and died January 30, 1908. He was a local trader and owned the store on Main Street that later, under the management of his son, became known as the W.B. Rand Store. The senior Rand was also a legislator, postmaster, and US customs agent (in Portland, when the Republicans were in office).

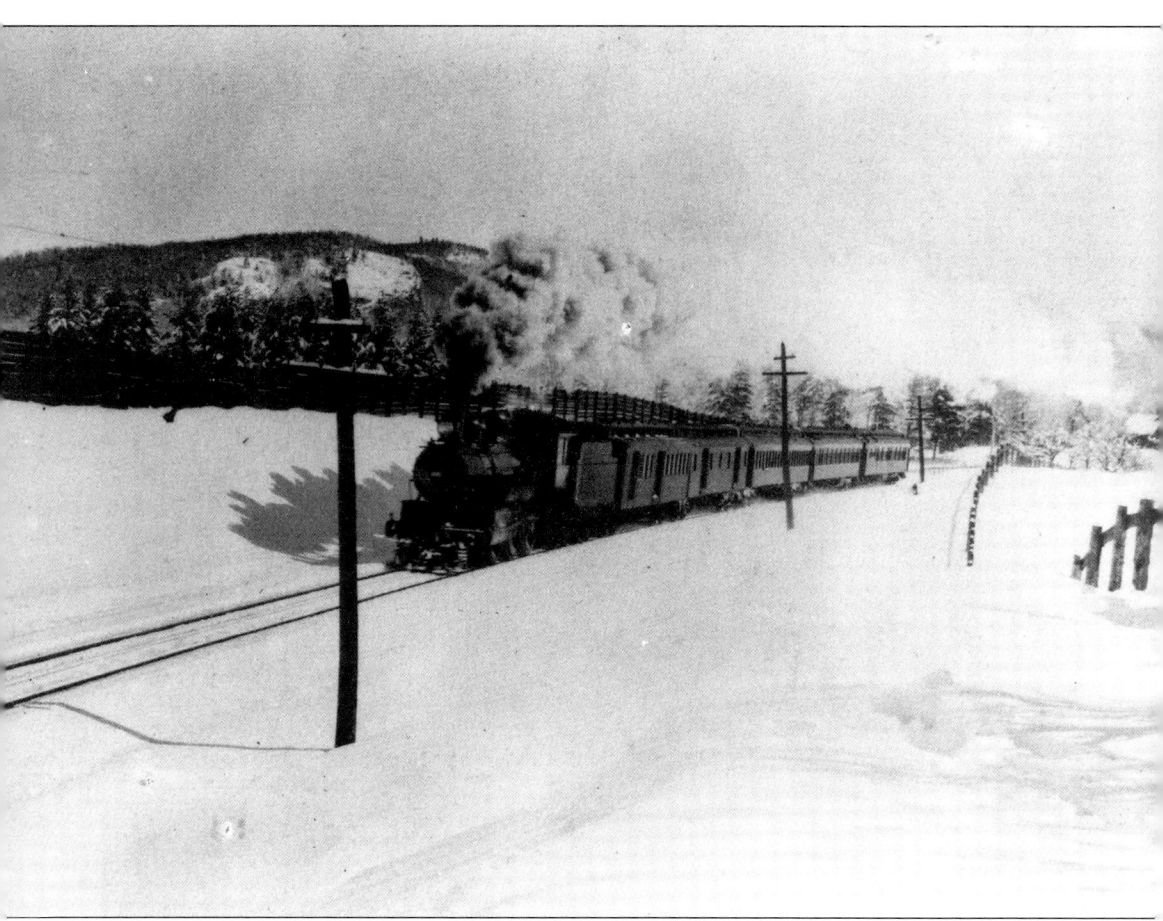

The "Up Train" out of Portland, chugging through the valley on its way to Montreal. Local people called all west-bound trains the "Up Train" and all east-bound trains the "Down Train." Buck Ledge is in the background, and in the distance to the right is Littlefield's barn.

This line was initially chartered as the Atlantic and St. Lawrence Railroad—the first major railroad line to eventually link the United States with Canada. By 1851 the line had been constructed from Portland to Bethel, and the little "Jenny Lind" (built by the Portland Company in 1850) made the first run through this valley to Bethel on March 5, 1851, bringing with it a turntable so that it could be turned around and headed back to Portland. Meanwhile, the Canadian portion of the St. Lawrence Railway (chartered March 17, 1845) was rapidly approaching the Vermont border. In July 1853, the first through-trains from each direction convened at Island Pond, Vermont.

On July 1, 1853, the Canadian St. Lawrence and the Atlantic Railway became a part of the Grand Trunk Railway of Canada (chartered on November 10, 1852). The Canadian Grand Trunk leased the American portion on August 5, 1853, for 999 years. In January 1923 the entire system came under the ownership of the Canadian National Railways, although the Portland line continued to be referred to as the "Grand Trunk Railway." (Nettie Maxim photograph)

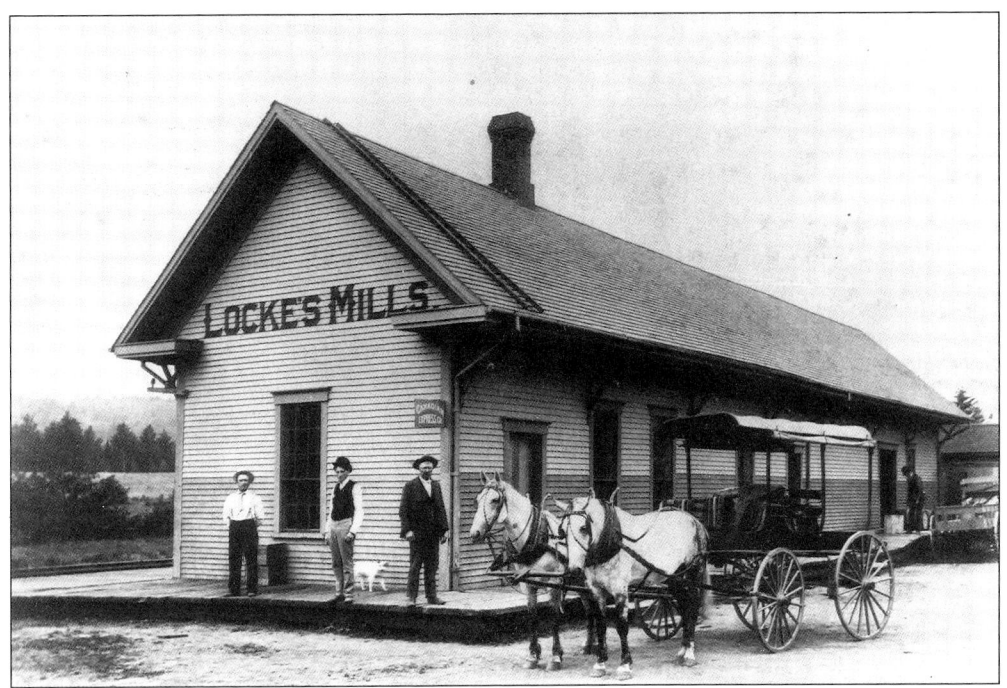

The Locke's Mill Railroad Station, c. 1907. From left to right are Joe Bolyer (agent), Elden Goodwin, George E. Farrar (stagecoach owner), and Moses Cummings (the photographer's father). The Hanover Stage made several runs per day to Locke's Mill to pick up passengers.

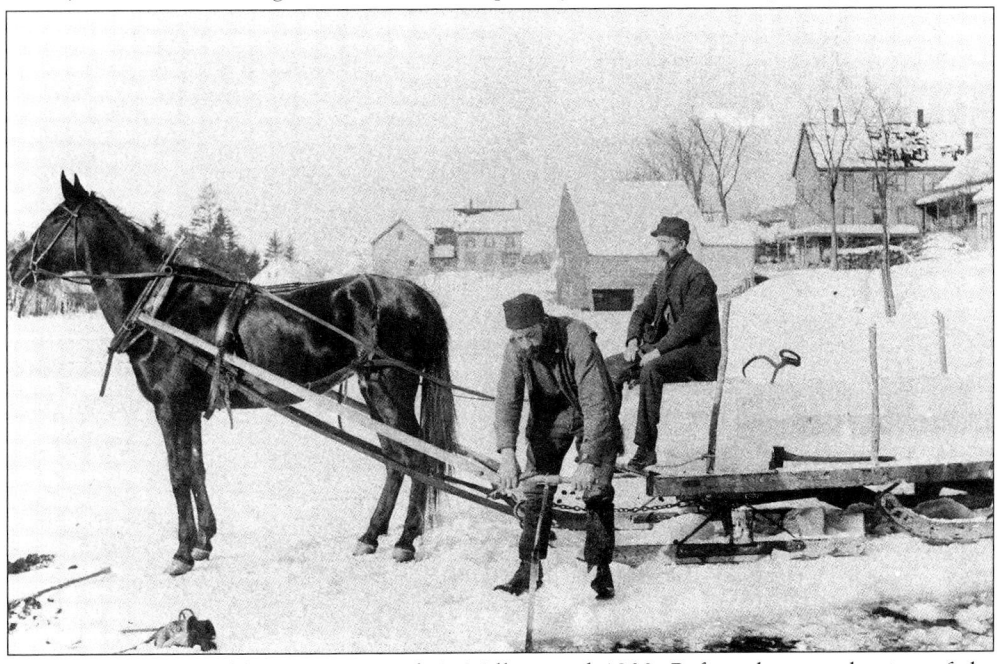

Harvesting ice on Alder River in Locke's Mill around 1900. Before the introduction of the refrigerator, every lake, pond, and stream of any size in the Oxford Hills (and throughout much of the state) was a beehive of activity once the ice became thick enough to harvest. Though hard to imagine now, ice was at one time a valuable export commodity here in Maine.

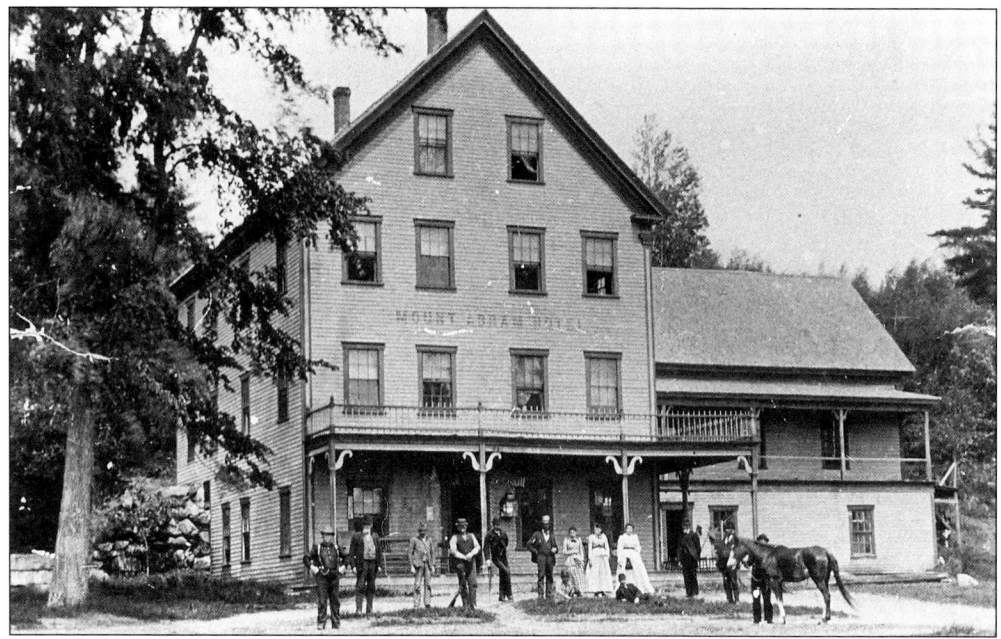

The Mount Abram Hotel in Locke's Mills as it appeared in the 1880s. Built in 1872 by Benjamin Warren Bean (father of L.L. Bean) on Route 26 overlooking the Alder River, it replaced the old Alder River House, which had burned.

A gathering on the bank of the Alder River around 1900. Posing in front of the Mount Abram Hotel are, from left to right: Guy Coffin, Robert Sanborn, Jennie Coffin, Herb Mason, Ethel Sanborn, and Harry Brooks. To the right of the hotel is the livery stable, and to the far left is the bandstand.

Benjamin Warren Bean and his 7-year-old daughter, Inez Alice, c. 1874. Benjamin was a farmer and carpenter on Howe Hill. He built and operated the Mount Abram Hotel from 1872 to 1873 and operated it until he sold it to D.A. Coffin c. 1877. He then moved his wife and their four children, including Leon Leonwood (L. L. Bean), to a hardscrabble farm in Allenville, a small hamlet of his native town of Bethel. He tenaciously fought a losing battle with a terminal malady, succumbing at the age of 44 on November 13, 1884. Inez was born at the Greenwood farm on Howe Hill in 1868. She married Eli Eugene Cummings, the son of Moses Cummings and his first wife, Julia. The couple lived in Norway and reared two daughters, Florence and Frances. Inez died in 1919.

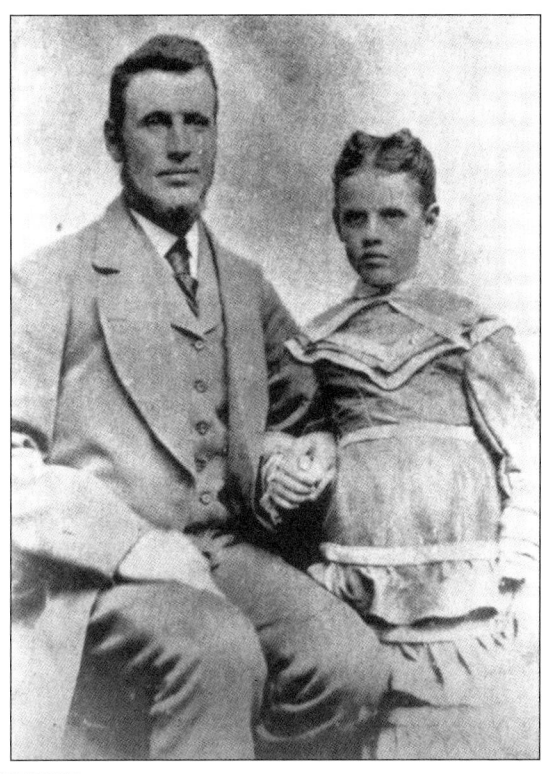

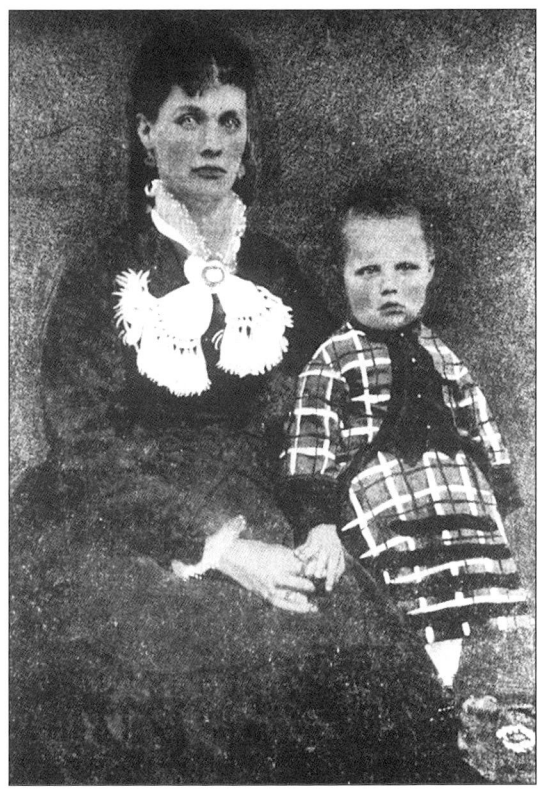

Sarah (Swett) Bean and her 3-year-old son, Leon Leonwood, c. 1874. Like her husband's, Sarah's health was also fragile, perhaps because she had borne six children. Nursing her husband and his death were too much for her. Four days after he died, she, too, departed from this earth, leaving L. L. and his five siblings orphans. Living with neighbors and relatives, L. L. worked on farms in the summer, earning no more than $12 a month, and attended school during the winter months. He earned his way through high school at Kents Hill by selling bars of soap. L. L. had an abiding passion for the outdoors and for hunting, fishing, and trapping. But one thing he did not enjoy was tramping about with cold, wet feet. With a loan of $400 from an older brother, Otho, in 1911, he invented and patented the Maine Hunting Shoe, which became the cornerstone of L. L. Bean of Freeport. He died in 1967.

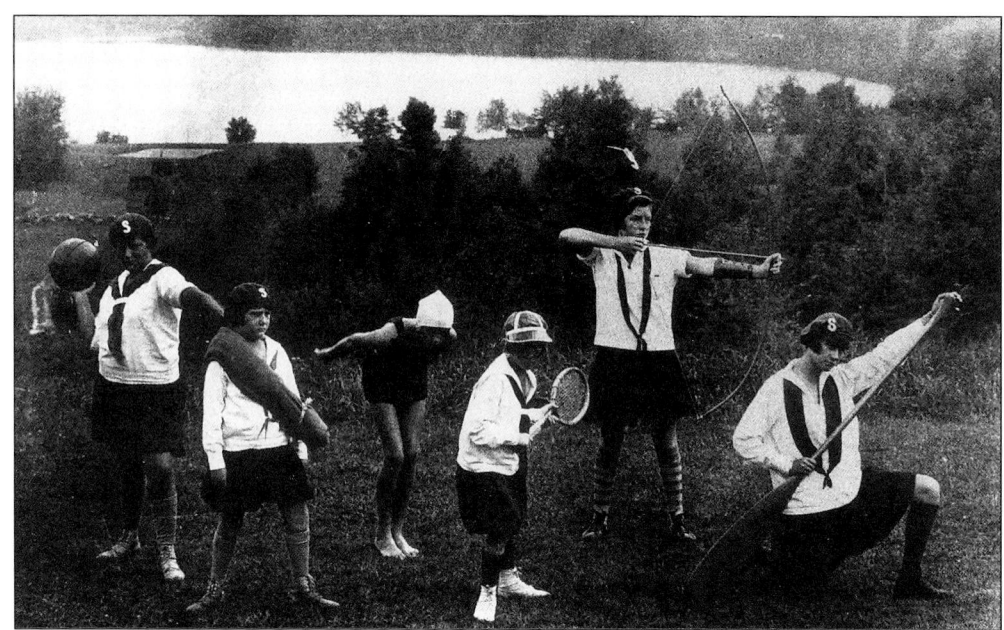

Camp Sebowisha on Indian Pond, c. 1925–1935. Miss Ethel Hobbs was a native of Gorham, New Hampshire, but she spent most of her life teaching school on Long Island, New York. Miss Hobbs purchased the old Dustin Bryant place between 1920 and 1925, and she operated a girls' summer camp from there from 1925 to 1935, with the majority of campers coming from the Long Island area. After her camp days, Miss Hobbs continued to vacation here during the summer until her death in the early 1970s

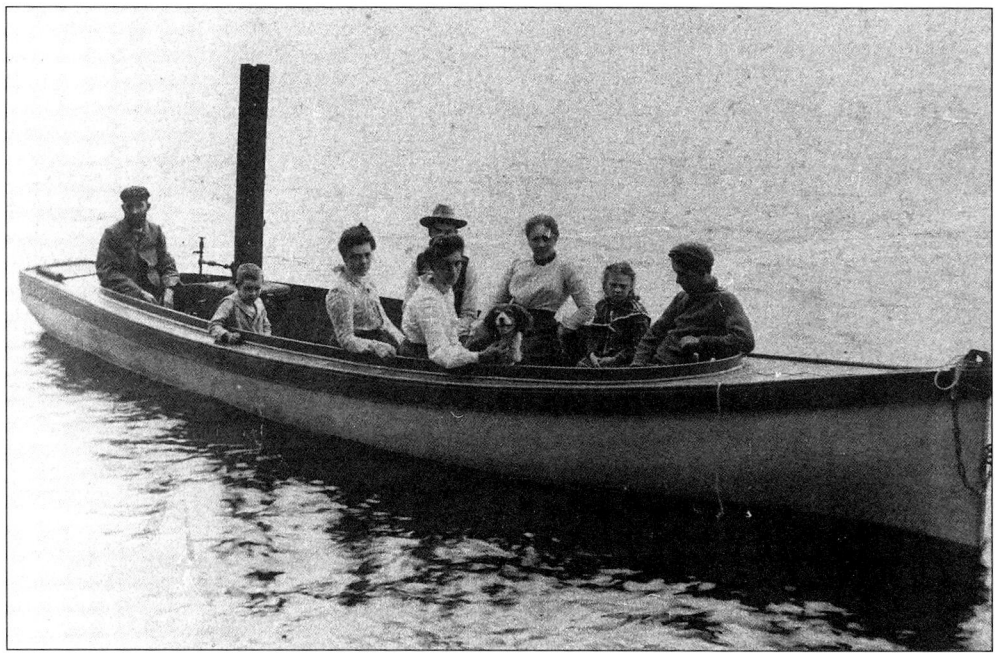

North Pond on August 14, 1902. This area is located in Hamlin's Gore. (A gore is a surveyor's mistake in which a parcel of land was left out.) The steamboat on the pond was built by Dexter Peverly, Raynor Littlefield's grandfather. The boat was kept at Littlefield's landing on North Pond.

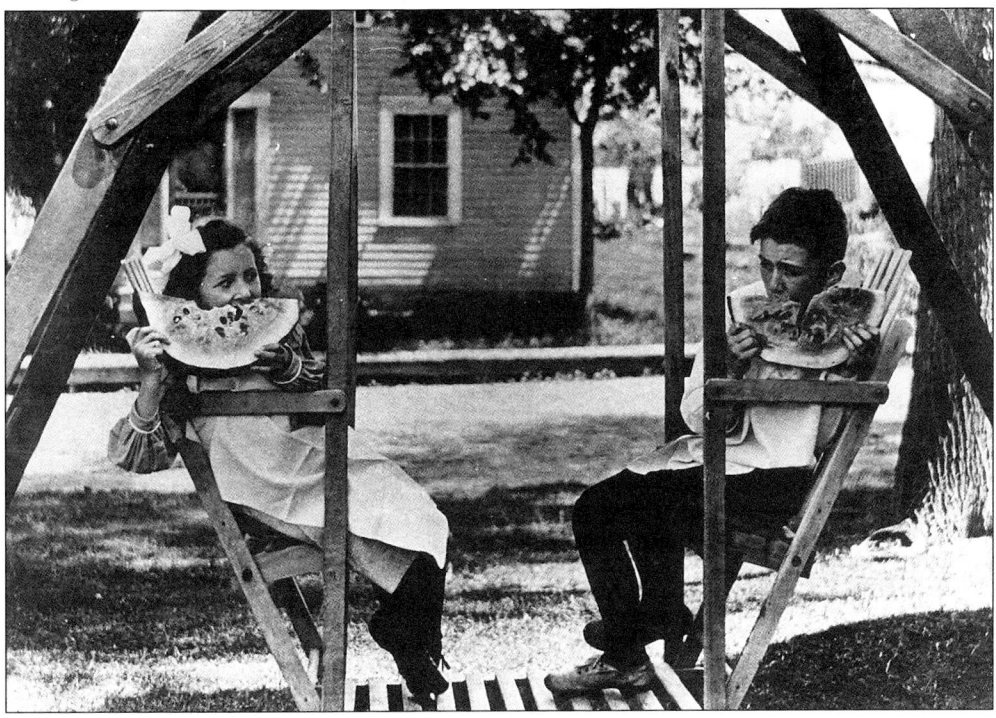

Fishing on South Pond in Greenwood, c. 1900–1910.

Ruth Stowell and Dana Grant, Jr., are enjoying watermelon, a special Fourth of July treat, c. 1907. The building in the background, built between 1840 and 1850, is the present home of the Greenwood Historical Society.

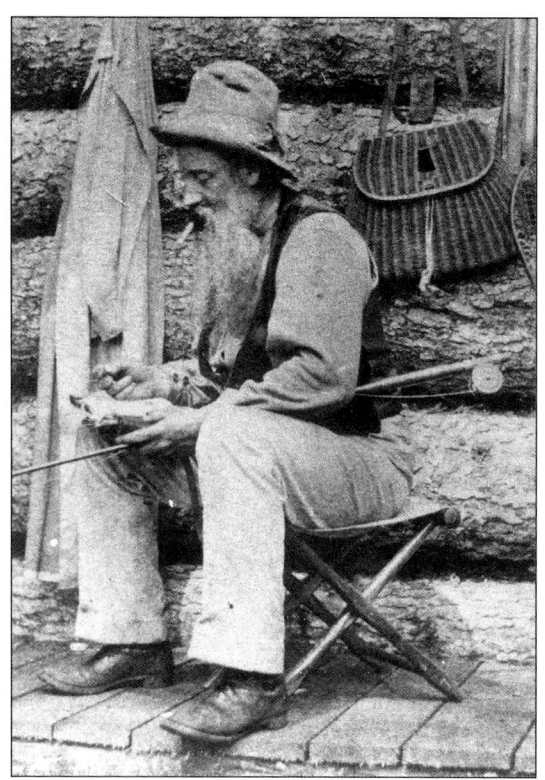

Fishing in Greenwood and throughout the Oxford Hills provided both recreation and food for the local populace and drew sportsmen to the area from other states. Francis Emery Cole came to the area every summer from New Hampshire to try his luck at wetting a hook. He usually stayed with his niece, Mrs. Ruth (Poole) Young, in Locke's Mills. In this *c.* 1890–1900 photograph, he is concentrating either on threading a line through a fly or baiting his hook.

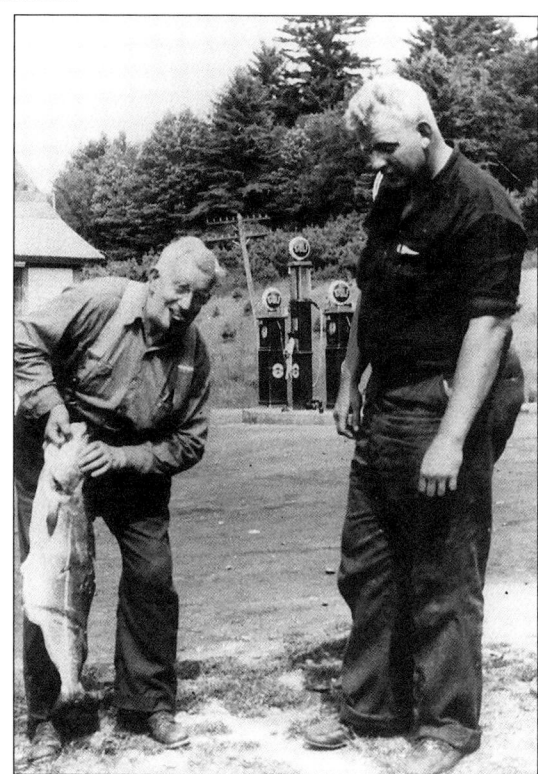

The big one that didn't get away. George Tirrell, photographed in August 1936, is holding a huge lake trout he caught, while his son Lewis looks on in disbelief.

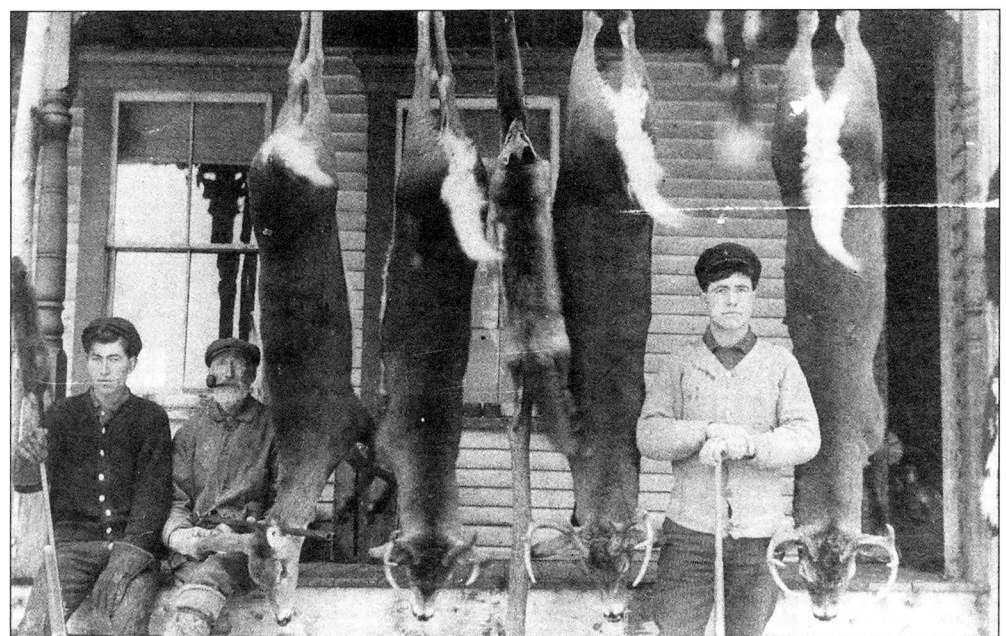

Hunting has also been a popular form of recreation throughout the Oxford Hills, and many local families depended almost entirely on wild game as their source of meat. A few still do. Shown here, from left to right, are Ernest Day, George Will Day, and Herb Day, relaxing after a very successful hunt, c. 1900–1910. One could wear nondescript clothing then without much fear of being mistaken for a deer by a negligent, overzealous hunter.

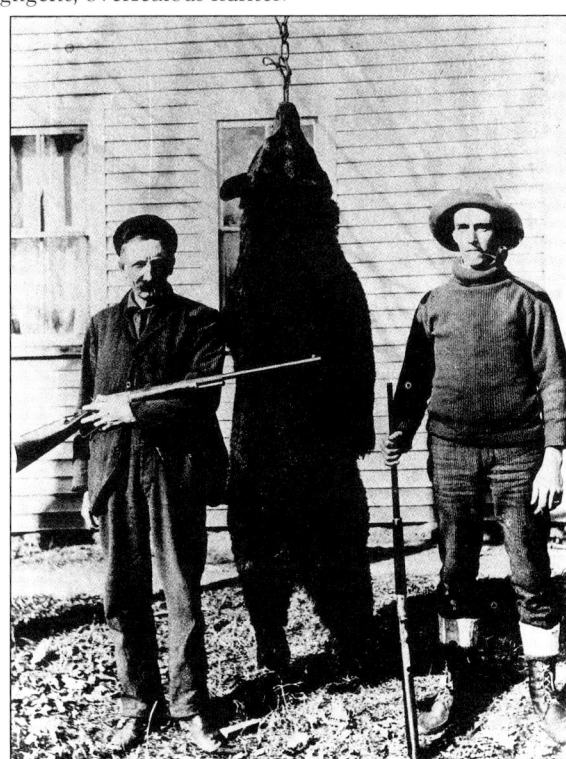

Roscoe Cummings and his son Elmer stand proudly beside a large black bear they shot with their Winchester carbines, c. 1900–1910.

The Greenwood Liquor Agency in 1903. Each town in Maine had a liquor agent who was sanctioned by Augusta to sell liquor. Augustus Hicks was the last licensed agent to sell liquor in Greenwood. Shown here, from left to right, are Augustus Hicks, Anjeannette Hicks, Jennie Coffin, and Cliff Swan. (Guy Coffin photograph)

Main Street in Locke's Mills, looking west, *c.* 1871–1878.

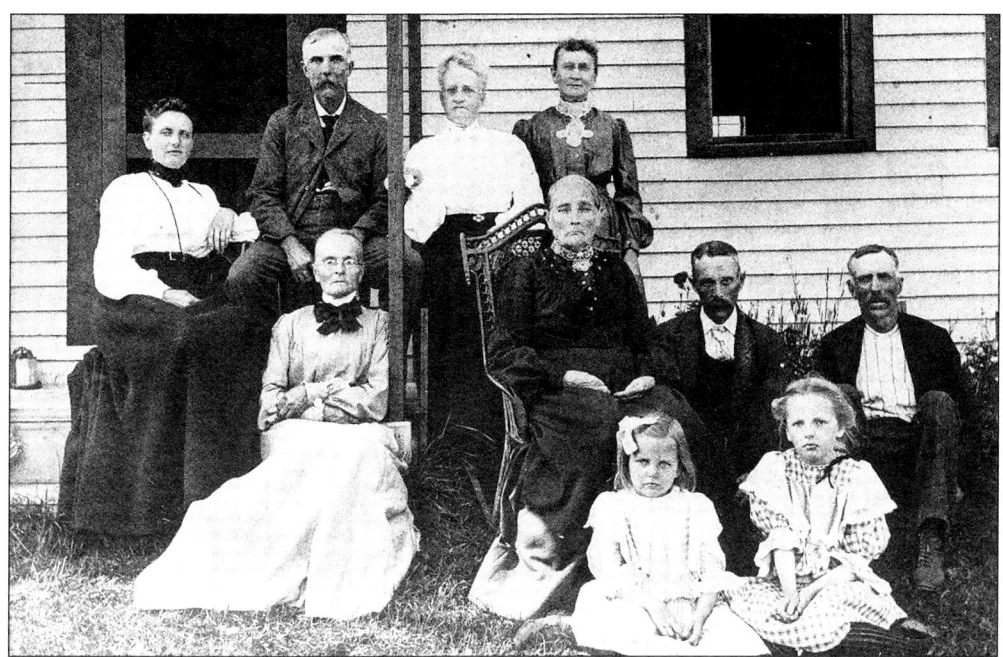

Family traditions were strong here in the Oxford Hill communities and remain so today. Here the Swift family is holding a gathering at the Swift Homestead on Howe Hill Road in Locke's Mills, c. 1900. Shown are, from left to right: (front row) Mary Elizabeth Swift and Georgia Marion Swift; (middle row) Emily S. (Swift) Bennett, Joanna P. (Jordan) Swift Libby, William Cullen Swift, and Nelson Seth Swift; (back row) Martha Lenora (Rand) Swift, Walter R. Swift, Mary Elizabeth (Swift) Demond, and Laura H. (Brownell) Swift.

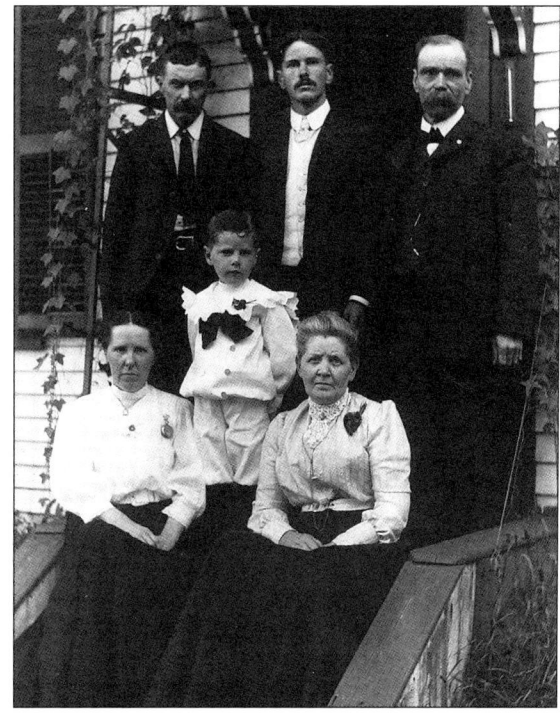

A gathering of the Fairbanks family, c. 1904/5. Shown are, from left to right: (front row) Maude (Fairbanks) Lapham and Emma O. Fairbanks; (center) Carlton Lapham; (back row) Mark K. Lapham, Cleve Fairbanks, and Joe Fairbanks.

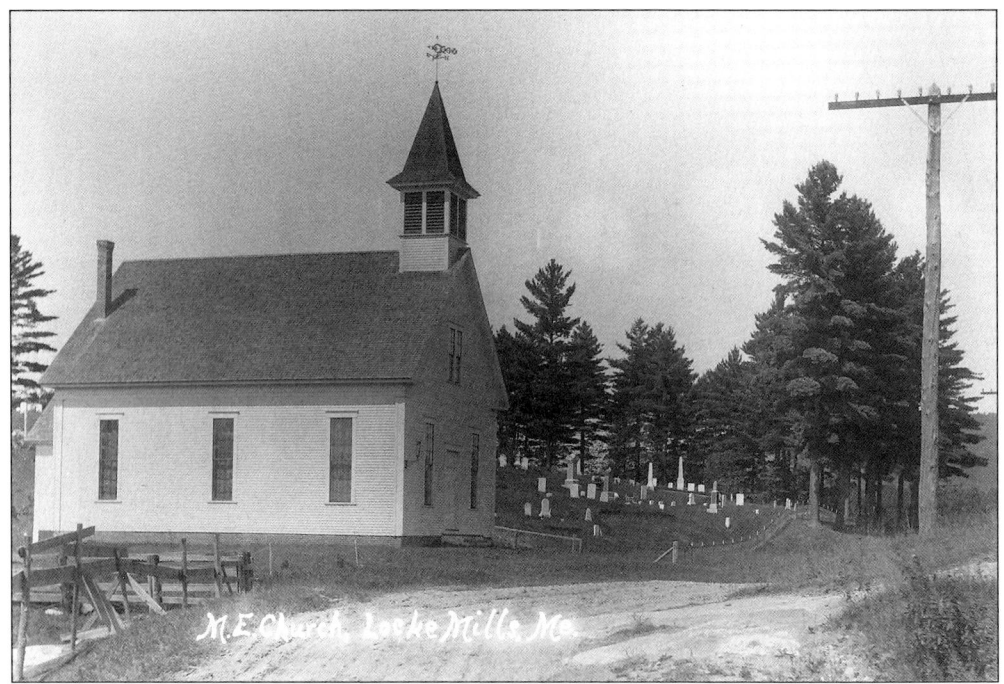

The Union Church in Locke's Mills, *c.* 1908. The church was a vital part of every community in Oxford Hills. Union Church was built in 1883/4, but the cemetery had been laid out in 1851. Samuel B. Locke, Jr., donated the land and laid out the cemetery, but it was many years before the meeting house was erected. From around 1870 to 1884 Currier Hall was used for worship services.

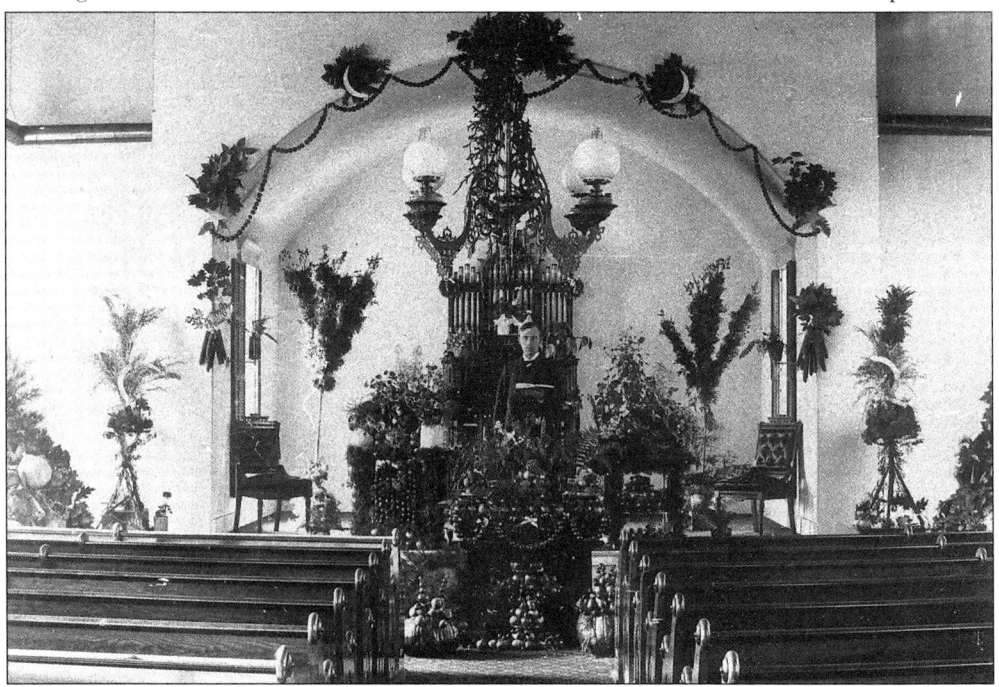

Union Church, *c.* 1894. The inside of the church is decorated for a harvest service, which usually occurred in October. Reverend Rich was the minister at this time.

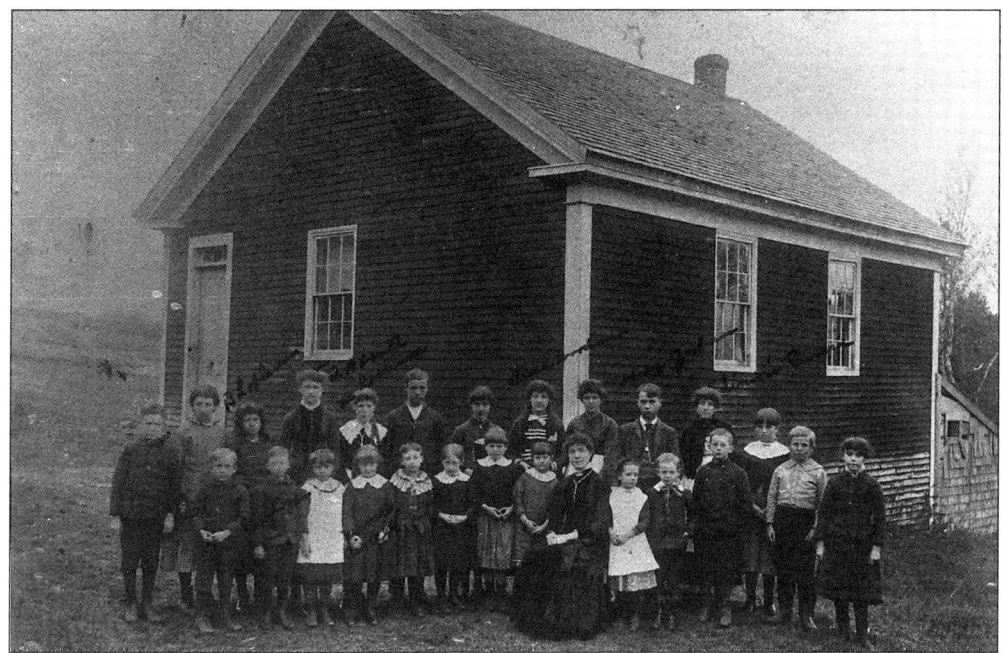

There are many still living today who recall the rich and endearing experience of attending a one-room district school. The Alder River District 16 School on Main Street in Locke's Mills was well attended in 1885. The building was constructed between 1842 and 1855 by Erastus Hilborn and cost $125. Classes had previously been held downstairs in the cellar/kitchen of Mr. Locke's place. The Alder River School closed in 1890 when a new school was constructed across from the mill. Some of the children are Guy Coffin, Mabel Herrick, (?) Abbott, Tena Young, Harry Jordan, and Linnie (?).

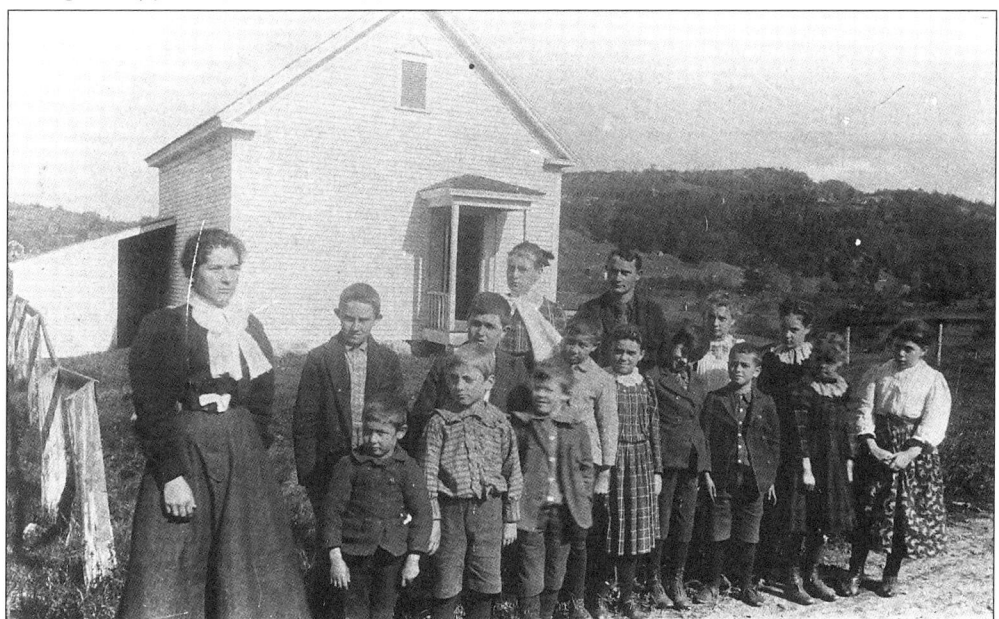

Miss Doughty with her students at the Tubbs District School in the southeastern corner of Greenwood, c. 1900–1902.

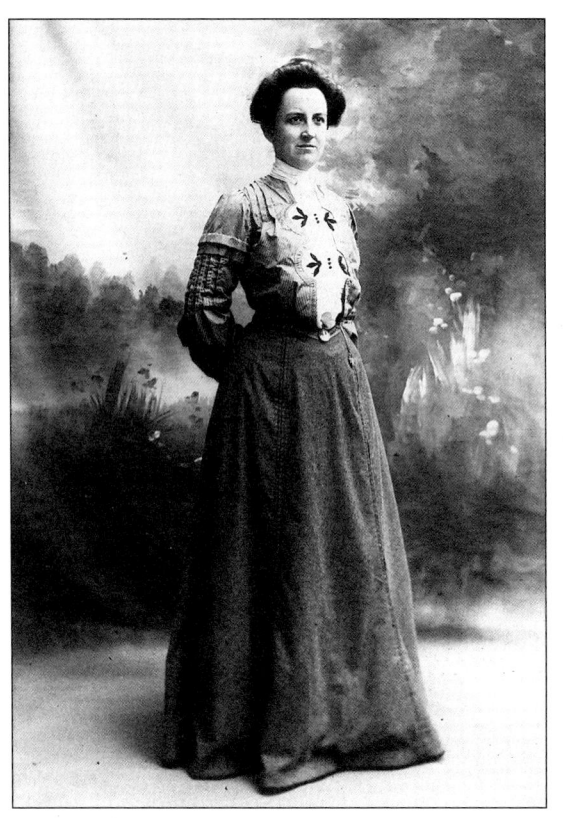

This superb self-portrait taken in 1898 exemplifies the extraordinary skill of Nettie (Cummings) Maxim with a camera. Born Nettie Cummings on August 1, 1876, she attended school on Bird Hill and at Gould Academy. She taught school briefly before marrying Howard Maxim of Paris Hill. The couple lived on her folks' farm on Bird Hill, about a mile up from Locke's Mills. It was at some point after her marriage that she took up photography as a hobby and very quickly evinced a real talent with the camera, especially as a portrait photographer. This photograph is also a testimonial to her inherent artistic talents, which enhanced her photography. She painted the backdrop for this photograph and designed the dress she is wearing. Her promising career ended tragically when she died of diphtheria in 1910.

On a beautiful summer's day a year before her death, Nettie Maxim captured with her camera two of her three children, Walter and Winnie, at play on Bird Hill amidst a sea of daisies. This photograph, entitled "The Daisy Field," has been singled out as one of her very best works of photography and is a paradigm of her innate love for nature. For more about this versatile lady and the Maine she loved so dearly and preserved for posterity, we refer you to *Maine Life at the Turn of the Century Through the Photographs of Nettie Cummings Maxim*, also published by Arcadia.

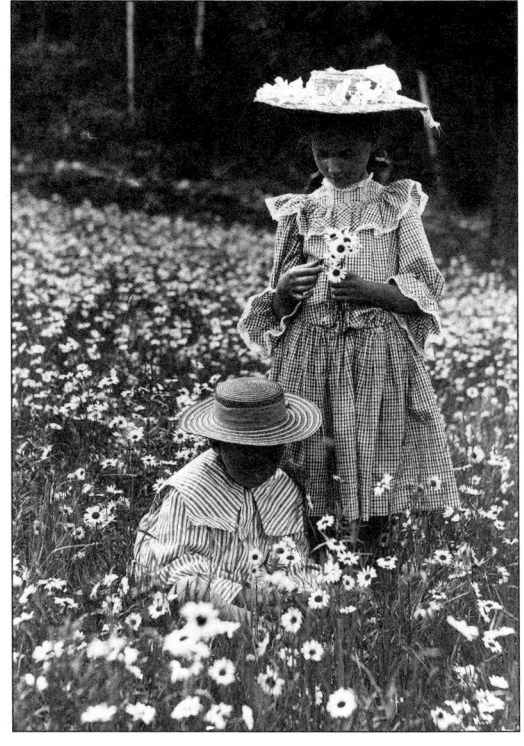

A family picnic at the popular Greenwood Ice Caves in 1906. This family outing became a frozen moment in time thanks to Nettie Maxim and her camera. From left to right are Nettie's daughter Winnie Maxim, niece Frances Cummings, sister-in-law Inez (Bean) Cummings, half-brother Eugene Cummings, husband Howard Maxim, father Moses Cummings (a Civil War veteran), younger son Walter Maxim, and older son Earle Maxim.

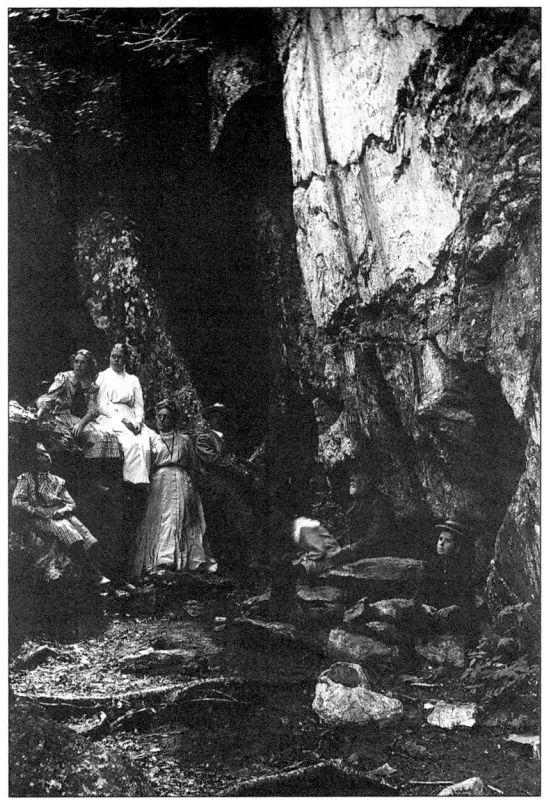

Little Doris Goodman smiles happily for Nettie Maxim, c. 1906.

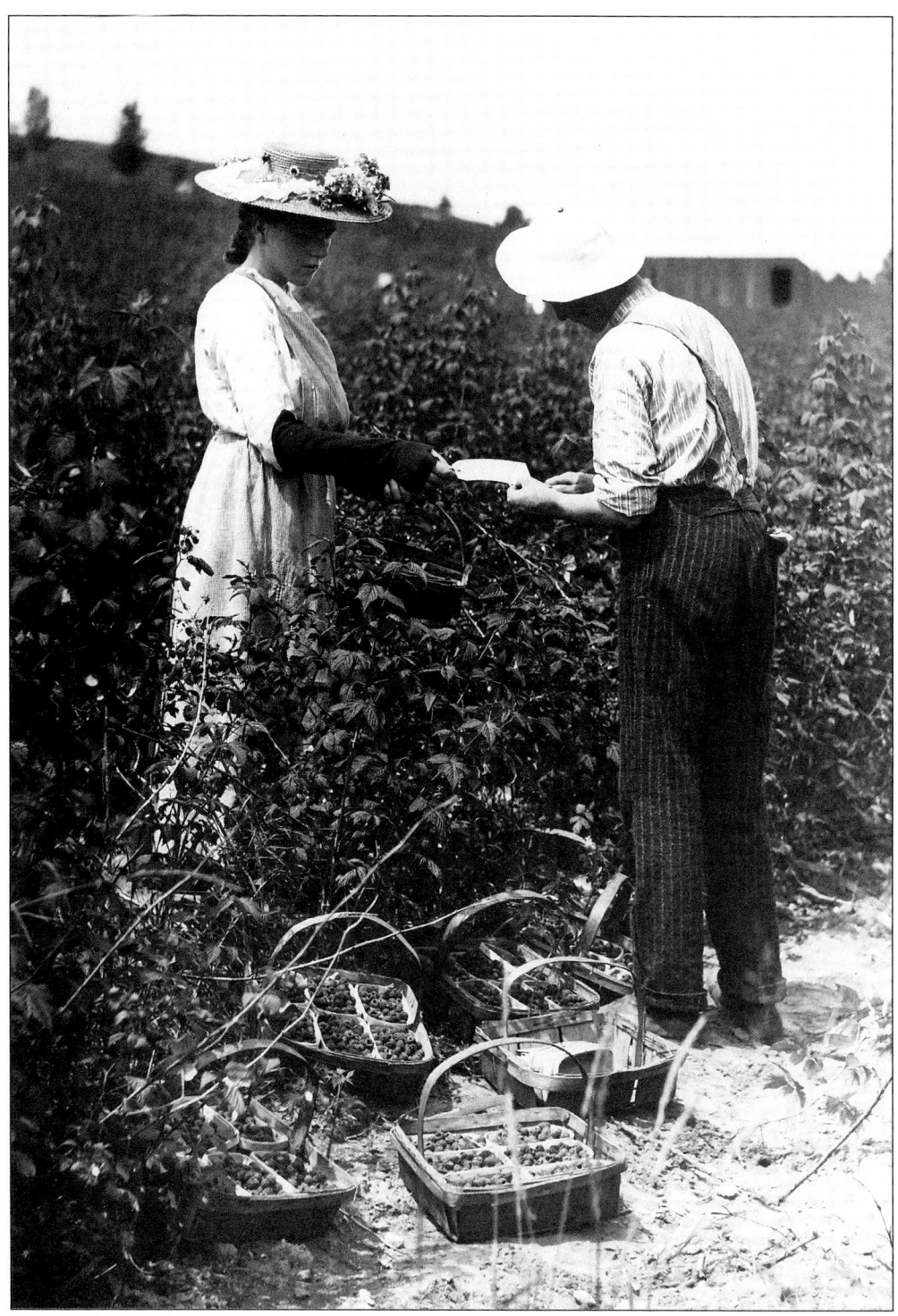
Berry pickers at the Maxim Farm on Bird Hill as photographed by Nettie Maxim, c. 1905–1910. The pickers are Emma May Connell and Arthur Herrick. The Maxim Farm abounded with raspberries and blackberries.

Two

Norway

First Settled: 1786
Incorporated: March 9, 1797
Population in 1990: 4,756
Area: 52.43 square miles
Principal Settlements: North Norway, Norway Lake, Ward 8

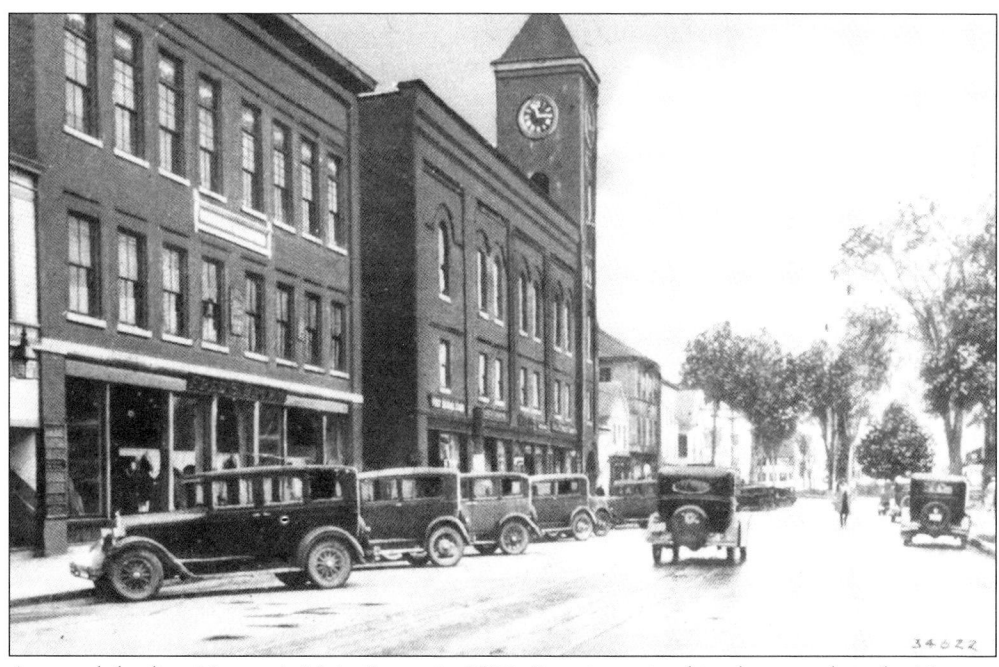

Automobiles line Norway's Main Street in 1929. Prominent in this photograph is the Norway Opera House with its imposing clock tower, constructed shortly after the 1894 fire.

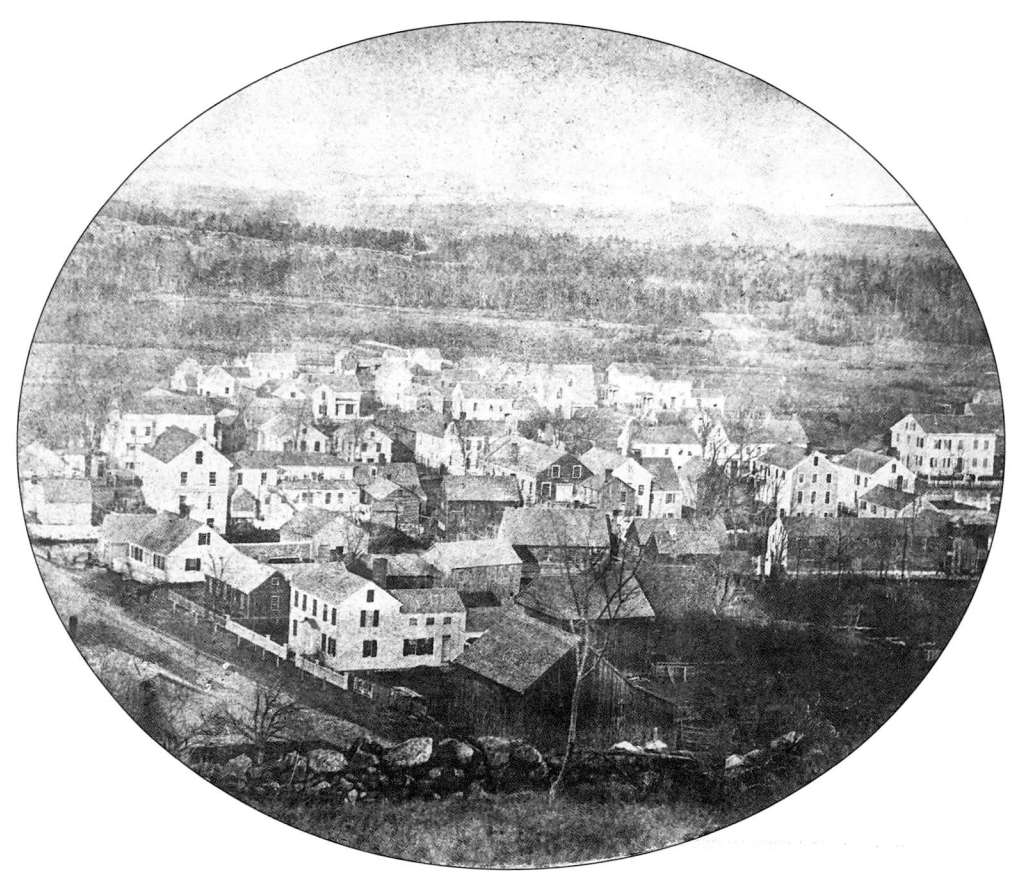

Norway in 1856. This bird's-eye view, said to be the oldest extant photograph of a community in the state of Maine, was taken by Addison Verrill, a naturalist and Yale professor. Addison Verrill's father was Byron Verrill, the first principal of the Norway Liberal Institute—a private school that in the late 1850s became a public high school. The senior Verrill and his students (all boys), on one of their biannual trips to Europe, were introduced to the "shadow box," and they returned with one to Norway. This photograph of Norway village was taken by Addison from the north side of Pike's Hill. The large white building to the far right is the Rust Mansion, built by Henry Rust (1737–1812), the original proprietor of the Rustfield Plantation (founded in 1786). Two years after this photograph was taken, the stately mansion was destroyed by fire.

Rustfield, combined with the Cummings' Purchase, Waterford Three Teirs, and Lee's Grant, was incorporated as the town of Norway in 1797. The name Norway, however, presents a bit of a mystery since there were no settlers from Norway. Because the Little Androscoggin River has three falls at the point that it runs through the town of Norway, the local citizens intended to adopt the name Norridge, a modification of the Indian word "norwege," meaning "waterfall." But Norridge was interpreted to read Norage by the state (Massachusetts at the time) which granted the incorporation in the name of Norway. Locally, the poor handwriting of the eighty-year-old town clerk was blamed for the error. (It is interesting to note that the Norwegian term for "Norway" is "Norge.")

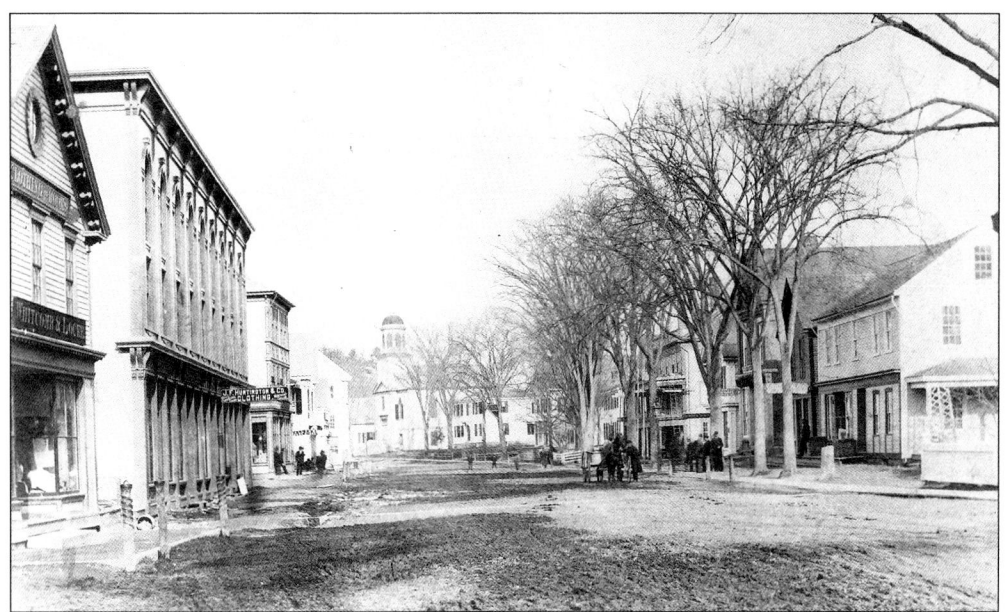

Main Street, c. 1882. Whitcomb and Locke (left) were making men's clothing in town at the time, and the outlet for Huntington and Company can be seen next door in the wooden building (built in 1881), which eventually became known as the Opera House. Next to it is the Frank P. Stone Drugstore, the only building in this block to survive the 1894 fire. The protrusive spire on the Universalist Church was taken down in 1913. Dennis Pike is seen here with a horse and wagon going door-to-door picking up wood ashes to be taken to his house and made into both hard and soft soap.

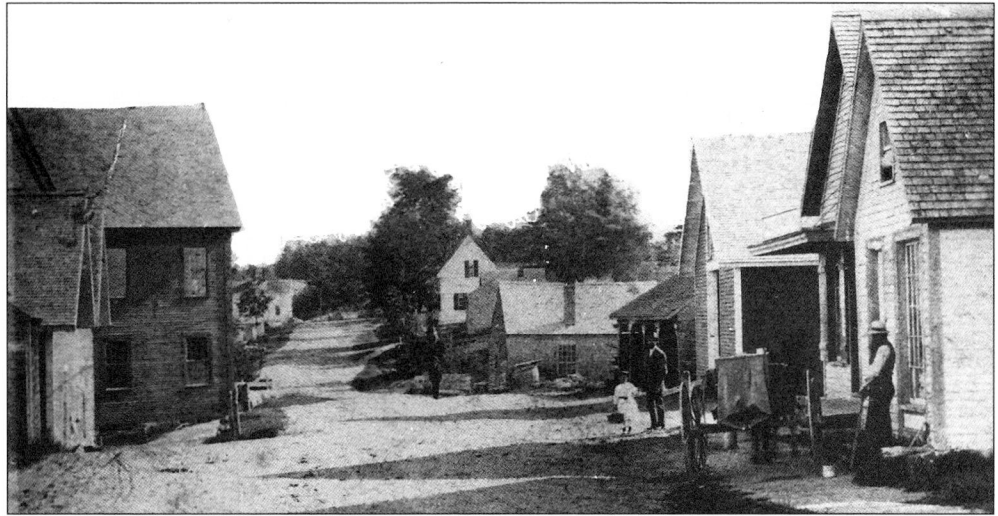

The Lower Falls, c. 1890. This settlement on lower Main Street, where Swan Supply is located today, has also been known as Fiddyville and Ward Eight over the years. Most of the people who lived in this section of Norway were from Cape Breton Island and Nova Scotia.

The building to the left was a novelty mill; at one time, there was a paper mill located on the site. To the immediate right was a store owned by Titus Olcott Brown, which sold hoes, stoves, and other implements made in a nearby foundry. Most of these buildings were torn down in 1940 to make way for new buildings and a cement highway to Portland.

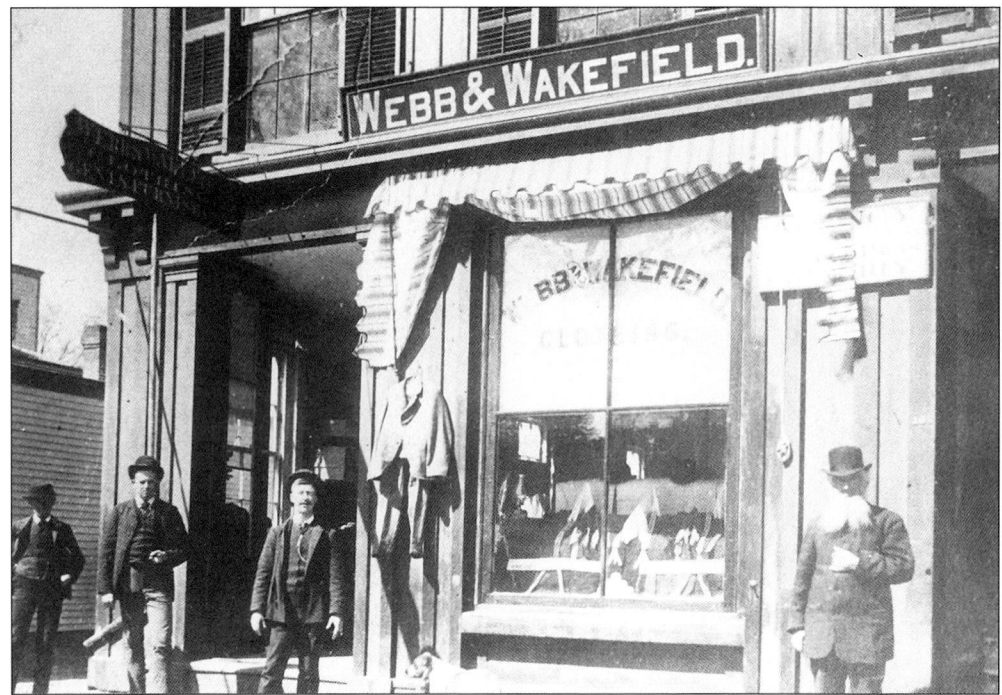

Main Street in Norway, c. 1903. Webb and Wakefield was a clothing store located in the Ezra Beal Block on Main Street. Theodore Webb, a son-in-law of Ezra Beal, can be seen standing in the doorway of his store. The second floor of this building housed the offices of Dr. Harry Jones and several other dentists.

The Thibodeau family, c. 1920. The lady in the center with the bow on her dress is Tessa Thibodeau, still fondly remembered by the older generations in Norway. She taught Norway's third graders for about forty-three years.

Seated in front without a hat is her grandfather, Orrington Cummings, a remarkable person and an excellent businessman, who for many years ran a livery stable on Danforth Street. Even though he lost everything in the fire of 1894, he rebuilt and adjusted to the changing times by making the transition from carriages to automobiles and then into trucking.

The Pingrees were a prominent family in Norway. The elder Pingree, sporting a white beard, is posing in front of Pingree Bakery, which was operated by his son and daughter-in-law. Unfortunately, all of these buildings were destroyed in the 1894 conflagration, and Mr. Pingree was forced into bankruptcy. He died shortly thereafter.

The interior of the store owned by Lewis Brooks, c. 1921. Besides selling what was then everyday dishware (displayed on the upper shelf to the left), the store sold fruit, dry goods, and notions. Today this building is the Bar-Jo Restaurant on Main Street.

A scene around 1930 of Norway's most distinguished landmark, the beautiful $4^1/_2$ mile Lake Pennesseewassee (Norway Lake), which extends to Greenwood.

It was not until 1893 that people in the area first began to realize the potential of the lake for recreational purposes, and the Bass Island Club was organized so that local men could go there to swim, fish, and socialize. Soon thereafter, lots were surveyed and several cottages were built. Since there were no roads leading to them, the property owners had to be conveyed back and forth to their camps and cottages by Edmund Ames in his homemade steamboat, named *Pennesseewassee*. If they needed groceries, they would hoist a flag and Ames would pull in, pick up the grocery lists, and later deliver their groceries. He also gave tours around the lake.

Oxen and horses were still prevalent in the Oxford Hills in the 1930s, and really were not phased out until after World War II.

Edmund Ames' sidewheeler, the *Pennesseewassee*, which provided boat service around the lake from about 1907 to 1931, is seen here at the boat landing at the head of Main Street, before the bridge was constructed. With the introduction of private boats on the lake, the services rendered by Ames were no longer needed, and the *Pennesseewassee* was transported to Harrison, where it plied the waters of Long Lake.

The buildings in the background along Pleasant Street were owned by C.B. Cummings, who controlled the water rights in this area. Skis and canoes were manufactured here.

Two local gentlemen relax at the Bass Island Club, directly opposite Bass Island, on the wooded shore of Lake Pennesseewassee. Each club member paid for a piece of stock, which gave him his membership rights. The club, founded in 1895, continued to exist into the 1940s.

The Beal's Hotel (1865–1961). Ezra Fluent Beal, a local builder and contractor, constructed this building as a home for his family. Just after the Civil War, Ezra was contracted to build railroad stations along the Grand Trunk. In 1863 the former Beal home was converted into a hotel, as Ezra thought the hotel would be a good business for his son, General George Layfayette Beal, who had distinguished himself during the Civil War as a regimental commander in the 12th Maine at Gettysburg. General Beal did not really take to innkeeping and soon left Beal's Hotel under hired management, to take a job as director of the Veteran's Civil War Pension Office for the State of Maine in Augusta.

The original Beal Homestead was only a two-story building. The upper stories were added to the hotel shortly after the turn of the century.

General George Layfayette Beal poses here around 1840 with his wife and their daughter Elizabeth. The Beals also had a younger daughter named Agnes Jeanette. Neither daughter ever married but they were significantly active in local affairs and politics. Both sat in on the board meetings of the Grand Trunk Railroad, mainly because their grandfather—Ezra Beal—was the architect and builder of most of the railroad's stations along the Maine line. They were also considerably active in the affairs of the local trolley that ran between Norway and South Paris.

The home of General George Layfayette Beal on Cottage Street. His wife, Belinda Thompson Beal, was a consummate horticulturist who maintained an exotic sunken garden behind the fence running parallel to the sidewalk.

41

A large contingent of local soldiers in front of the Charles Hathaway Lumber Mill preparing to

board Grand Trunk Railroad cars to fight in the Spanish-American War.

The shoe industry employed a large number of people from the Oxford Hills. This is the original building of the Norway Shoe Company as it appeared around 1866. It was constructed with money raised by public subscription. In all there were three sets of buildings.

The Norway Canning Company was a subsidiary of the Minot Packing Company. This photograph was taken around 1944 at the peak of its operation, when the company was canning creamed corn, shell beans, and succotash. The main building is today owned by Longley's Hardware Store and is used for storage.

Blacksmiths were an important element of any town and hamlet; at one time, there were twenty-one blacksmiths in Norway alone. This photograph, taken at S.J. Record's Shop on Beal Street, dates to about 1900.

The Horne Tannery was located on Main Street, and by the time of the 1894 fire it had already closed down. The chimney was used as part of the old Norway Fire House: it became a drying shaft for the hose.

A panorama of Lake Pennesseewassee, c. 1898. Here, Margaret Libby poses on a stonewall near Upper Road (Country Club Road) for her daughter, Minny Libby. One of Minny's photographs eventually appeared on the cover of the December 2, 1940, issue of *Life*, which contained an article about her and her photography.

The well-manicured fields and stone walls reflect the affinity the farmers in the area had for the land, and indicate how actively they were still farming around the turn of the century. In the last half of this century forests have reclaimed these fields, and it is now impossible to view the beautiful lake below from where Mrs. Libby is sitting in this photograph. The first house to the left (near the shore) was the home of Dr. Charles Ashbury (C.A.) Stephens, known as a pioneer in American gerontology and the author of eighteen books of fiction, five of non-fiction, and over three thousand short stories.

Norway and South Paris were serviced from July 1895 to 1918 by a trolley car line owned and operated by the Norway & Paris Street Railroad, a subsidiary of the Oxford Light and Power Company. The line ran from the head of Main Street in Norway to Market Square in South Paris. "Number 6" was a summer car; all winter cars were enclosed for warmth.

Mr. and Mrs. David Holden are on their way into town, c. 1907. The couple operated a little shop directly across from the Norway Packing Company.

"The Dummy," as this locomotive was called, pulled cars between South Paris and Norway. This photograph was taken around 1890.

The railroad yard of the spur of the Grand Trunk Railroad and the station built by Ezra Beal are shown here about 1920. Passenger service remained constant until 1946; trains would pull into the Norway Station and have to back up to return to the South Paris Station. Freight service on the spur terminated only recently.

The old "Oxford Bear," which dates to about 1851, is shown here in a 1941 parade. It was in use by the local fire department for a number of years; recently, volunteer firemen purchased this rare piece of Americana and restored it, and today it continues to be a major attraction during local parades. The two-wheel attachment was used to carry the hose.

The Norway Volunteer Fire Department posing in the spring of 1932 in front of the fire station. Built in 1851, a portion of the original building was destroyed by fire in 1894.

49

The circus comes to town! One of the major annual events in Norway was the arrival of the circus. In this *c.* 1915 photograph, "Hunt's Silverplate Shows" parades through Norway, featuring a lion in the cage. The circus parade is passing by what would eventually become the parsonage for the Congregational Church.

Norway's panacea for almost every ailment was Brown's Instant Relief, which was considered by locals to be superior to Lydia Pinkhams, perhaps because the alcohol content in Brown's concoction was greater. Unfortunately for both Brown and his customers, the law soon caught on to the alcohol content of his mixtures, and Norway's popular proprietor was forced to discontinue making his famed Instant Relief. This photograph of Brown's vending machine was probably taken shortly before he was compelled to close down his operation in 1920.

Very early in the history of baseball, it became popular in the Oxford Hills area. Sponsored by the Radcliffe Shoe Company, the Radcliffes of Norway was a semi-professional team that played in the old Pine Tree League. The family names of many of these players are still prominent in the area today.

The Reverend Caroline Angell, known as the "Marrying Minister of Norway," is standing in the doorway of the Brown Homestead on Greenwood Road. She was the pastor of the Universalist Church from 1884 to 1904. The occasion was a summer picnic in the country at Norway Center.

The Universalist Church on the north side of upper Main Street was built in 1828, but the congregation was founded in 1799. In 1863 the building was raised and the lower story was added. This lower story, called Concert Hall, was used for town meetings.

The charter membership of the Weary Club of Norway, Maine, c. 1931. At the turn of the century many of the men in Norway gathered on a regular basis in the lobby of the old Beal's Hotel. In the late 1920s, during the winter when business slowed down considerably, the manager and owner of the hotel—a Mr. Seavey—closed the hotel and went south. This meant that the group of men had no place to congregate and swap stories. However, Fred Sanborn, the publisher and editor of the *Norway Advertiser*, died and left money for the construction and maintenance of a building where senior male citizens could spend their time whittling and socializing. A special stipulation in the charter stated that wood be made available for whittling, and that the members of what became known as the Weary Club (so named because the members were weary of their wives) perform one charitable work as a group each year. The club eventually had its own stationery, and on the letterhead was printed "The Weary Club of Norway, Maine—Makers and Dealers in Cedar Shavings, Social Gossip, Political Wisdom and Yankee Philosophy" (Fred Sanborn). Today there are twelve local gentlemen who still proudly proclaim membership.

"Let 'er rip!" Mellie would vociferate at the onset of a Saturday night dance at the Heywood Club up on Crockett Ridge, as he tucked his fiddle under his chin, stamped his feet, and began playing. Some say his music still reverberates down off the ridge on Saturday nights.

In 1925 Alanson Mellie Dunham and his wife "Gram" (Emma Richardson Dunham) were the honored guests of Henry Ford and entertained the Fords as well as Michigan's elite at a dance at the Ford Engineering Laboratory. He went on to gain further fame on the Keith-Albee Vaudeville Circuit and appeared in nineteen US cities in twenty-two weeks for $100 a performance.

Mellie Dunham posing with some of his famous diamond-weave snowshoes. Long before Mellie Dunham's fame as a fiddle player extended beyond Oxford Hills, his snowshoes were in demand the world over. His craftsmanship was so superior that Commodore Robert Perry made a special trip to Crockett Ridge and ordered sixty pairs of snowshoes for his expedition to the North Pole in 1909. Some of these snowshoes are on display at the Smithsonian Institute Museum, and some can be seen at the Norway Historical Society.

The Heywood Club is a local social club where dances, suppers, and other social functions are still held. In the days when many folks in the area belonged to the local Grange, the Heywood Club was a sort of insurance group. If members became ill or had an accident, other members would care for them. Built in 1907, the club was named after John Heywood, a popular early twentieth-century English writer.

Stinson's Bridge (*c.* 1937) and a 1930 Buick. Stinson's Bridge on Route 26 was one of two covered bridges that graced the town of Norway, both of which have long since vanished. The road in front of the bridge (to the right) led to the town of Oxford.

A horse-drawn snow roller is shown here passing in front of the Cole House at the head of Main Street. Packing the roads down in winter was the common way of dealing with heavy snow until the automobile gained popularity in the 1920s.

The flood of 1936. The Little Androscoggin River overflowed its banks in 1936, which was a terrible year for floods throughout much of Maine, especially along the Androscoggin and its tributaries. As you can see here, Norway was a victim of the deluge. The building in the center of the background is the Norway Shoe Company, and the B.F. Cole Shoe Company is to the right.

A major logging operation at a portable mill in the early 1900s. The sawmills, more than any other industry, set the communities of the Oxford Hills in motion. It is early winter in this scene and hauling out logs on horse-drawn bobsleds was a relatively easy task; as winter progressed and the snow became deeper, transporting the logs was almost impossible.

Vivian Lord and Verne Rich are posing with a colossal snowshoe (weighing 50 pounds) for Jack Quinn, a local newspaper reporter. A sign was attached to the snowshoe which read "Snowshoe Capital of the World." It also gave the elevation, the population (at the time it was 2,873), and pointed out the fact that Norway was half way between the Equator and the North Pole.

Norway's fame for its snowshoes spread rapidly after the Admiral MacMillan and Robert Peary expeditions to the North and South Pole. All of the camping equipment, snowshoes, and skis used on both expeditions were products of Norway.

From about the end of World War I into the 1950s, Main Street would be closed off at times during the winter for snowshoe contests. One winter when there was no snow, sawdust was hauled down from the huge sawdust pile at the C.B. Cummings Mill and spread in a thick layer along Main Street so that the international snowshoe races could be held.

Three

Oxford

First Settled: c. 1790s
Incorporated: February 27, 1829
Population in 1990: 3,705
Area: 41.87 square miles
Principal Settlements: Oxford, Welchville

A panorama of Oxford Village taken from Allen Hill. Oxford was originally part of the town of Hebron, which was incorporated March 6, 1792. Both towns came from land that at one time was part of the Shepardsfield Plantation.

The original name for Oxford Village was Craigie's Mills, named after Andrew Craigie of Cambridge, Massachusetts. Craigie owned the Craigie House, which became the headquarters of General George Washington during the British siege of Boston; it would later become the home of Henry Wadsworth Longfellow. Craigie also owned a large tract of land in what is today Oxford and played a major role in developing the area around much of Thompson Pond.

Pleasant Street, looking south toward Thompson Pond, as it appeared in the early 1900s. On the left can be seen the Harriet Farnham House, the Locke House, the Congregational Chapel, the Congregational Parsonage, and the Lord and Starbird's Store. On the right side of the street the George Jones Drug Store is now the Village Green. Robinson Hall, owned by the Robinson family, was at one time used as a theatre where movies were shown for 10¢. The American Legion, K. of P., and the Grange all held their meetings here; Oxford High School's activities such as the graduation ball, graduation, and plays took place here as well.

A view of King Street in Oxford looking east in the early 1900s. This public road was built in 1833 by Colonel Samuel Hall King, a prominent early entrepreneur. Colonel King was born in the neighboring town of Paris and settled in Oxford Village around 1822, when it was still called Craigie's Mills. He moved his family to Portland in 1845. His youngest son, Marquis Fayette King, served for a time as mayor of Portland and wrote the *Annals of Oxford* (1903). The

Freeland Holmes Public Library, opened in 1914, provides a valuable service to Oxford residents as well as summer visitors.

Covered bridges were an important part of the Oxford Hills landscape for a century or more. This photograph shows the Oxford Village Bridge, which was constructed in 1838 across the Little Androscoggin River. It was replaced by a cement bridge in 1940.

Industry has been the cornerstone of Oxford's economy since the early 1800s. Joseph Robinson, who purchased the Oxford Woolen Company outright in 1863, was born in Leeds, England, the heartland of the British woolen industry. He arrived in Boston in 1838 at the age of twenty-seven, with only the clothes he was wearing and two copper pennies in his pocket. Today the mill is owned and operated by fourth and fifth generations of Robinsons.

The Grist Mill on King Street in Oxford hummed with activity throughout much of the nineteenth century as the water wheel generated power for the manufacturing of various wood products. Later, under the ownership of Edwin F. Richmond, the power was used to grind grain into flour and corn into meal.

The crew at Harper Mill takes a break from work for a company photograph. Harper Mill was built by John Harper in 1870 on the Little Androscoggin River in the section of Oxford known as Welchville. Wool was manufactured here until the building burned on September 20, 1891.

Fernald, Keene and True Company's Canning Factory, or the "Corn Shop," provided a dependable market for corn raised by the farmers throughout much of the region and employment for many locals during the canning season (which lasted from six to eight weeks). The factory closed shortly before the end of World War II. In the 1970s and '80s the Fox Brush Company manufactured brooms and brushes here.

The Ebenezer Rawson Holmes Farm was located on the road from Portland to Paris. The house was destroyed by fire in 1947.

A typical haying scene in the late nineteenth century. Gathering and storing the hay was an essential annual early summer activity on every farm, large or small, and involved everyone on the farm old enough to work. Here, the hay is being raked by hand into piles to be pitched into the horse-drawn hay wagon. This photograph was taken along what is today Route 26, just south of the bridge that spans the Little Androscoggin River in the town of Oxford.

Peter Billings working with his yoke of oxen around 1900. The house is presently owned by Orville and Eleanor Matthews Polland.

Working with steers at the Peter Thayer Farm in Oxford around 1900. Thayer, a veteran of the Revolutionary War, settled in Oxford in 1781 when both Oxford and Hebron were still part of the Shepardsfield Plantation. He was killed in 1788 when a tree he was cutting down for the construction of the barn fell on him.

65

The Centennial Celebration for the town of Oxford in 1929. The stage driver in the parade is Frank Grover. The ladies inside are Emma Holden, Mrs. Hall, Charlotte Hunting, and Alice Wilson.

The Oxford Station was a busy place around the turn of the century. In the early 1900s ten to fifteen locomotives thundered across the Oxford Plains every day on the Grand Trunk Railroad. This two-story station was built between 1882 and 1884. The station agent lived on the second floor. The last passenger train arrived and departed here on September 6, 1951.

The Caldwell District #6 School. Franklin Pierce taught here during the winter term of 1828, before eventually becoming the fourteenth president of the United States. This later building was constructed in 1852 and closed in 1925. In 1946 it was sold and converted into a private home before burning in 1969.

Students at the Caldwell School in the fall of 1918. Shown are, from left to right: (front row) Laurice Strother, Esther Caldwell, Melva Greeley, Annie Fuller, and Merritt Caldwell; (middle row) Marcus Strother, Caroline Strother, Josephine Strother, Annie Greeley, and Theresa Brown; (back row) Arthur Thayer. The teacher was Ernestine Maxim Corbett (not present).

67

The old Oxford High School. This building was constructed to replace the original Oxford High School, which collapsed in 1926. It ceased to be Oxford High School on November 19, 1965, when the town of Oxford became part of School Administrative District #17. The building has been extensively renovated and now serves as the town office.

The Oxford High School Class of 1934.

A gathering of Oxford veterans of four wars, c. 1943. Shown are, from left to right: (front row) ninety-five-year-old Civil War veteran George Jones; (back row) Kelsey Young (WWII), Otis Howe (WWII), Tim Coolidge (WWI), James Kane (WWII), and Wilfred K. Perkins (Spanish-American War).

The Oxford Cornet Band performing in 1886. Members of the band who appear in this photograph are James L. Holden, Porter Stewart, Frank Walker, L.C. Stone, William R. Farris, George H. Jones, Frank W. Lord, Eugene Burns, Ernest H. Boynton, Lester Faunce, Fred Jordan, George Kavanagh, and Walter Holden.

Kate Houghton Starbird is shown here busy at the switchboard in her home on High Street. Telephone service was first opened in Oxford in 1888, and in 1906 the Oxford exchange was installed here at the Starbird dwelling. Oxford was the second town in the state to join the Community Dial system, while Bryant's Pond was one of the last.

Four

Paris

First Settled: 1779
Incorporated: June 20, 1793
Population in 1990: 4,492
Area: 65.48 square miles
Principal Settlements: Paris Hill, South Paris

The first community Christmas tree was placed in the center of South Paris Village on December 25, 1916. (Ed Greene photograph)

Market Square in 1927 photographed by Ed Greene with his fisheye camera. From left to right are Porter's Store, Farrar Grocery Store, Bolster's, the Eastman Clothing Store, and the Andrews Hotel. The gas pump to the right was one of several owned by Myron Maxim.

When the General Court of the Commonwealth of Massachusetts officially established the town of Paris on June 20, 1793, Paris was in the County of Cumberland in the Province of Maine. In 1805, when the County of Oxford was formed, Paris became a part of that county;

The worst fire in the history of South Paris devastated everything in 1927 from the Pine Street

since Paris Hill was a thriving community and the center of social and commercial activities in the newly formed county, it was designated as the county seat.

Gradually, however, South Paris Village, with its more favorable geographic location, became the hub of economic activity—especially after the Atlantic and St. Lawrence Railroad elected to lay its rails through the village. In 1895, following a vote by the residents of Oxford County, the county seat was moved down the hill to South Paris.

area to what is now the Market Square Restaurant. One man perished. (Ed Greene photograph)

73

Market Square, South Paris, in the late 1860s. This is a stereopticon view of Market Square when Soldiers' Monument was in the center of South Paris; in the 1880s it was moved to Moore Park. On the right is the Andrews House, which later became the livery stable. The road leading off to the right, beyond the young elm (which eventually grew into a majestic shade tree), is the road to West Paris.

A photograph taken sometime in the late 1880s or early 1890s of the Shurtleff Drug Store (on the left) and the Odd Fellows Hall (to the right). The latter housed many different businesses on the ground floor; the second floor was used as a motion picture theatre, and the top floor was where the Odd Fellows met.

A view of Market Square on Decoration Day, May 30, 1913. The store on the left is Frothingham's. On the right can be seen the new stone Deering Memorial Methodist Church, which was built in 1911.

A Grand Trunk passenger train thunders over a bridge to the southwest of South Paris. The impressive stone abutments, which are still in use today, were constructed under the supervision of Ansel Dudley, who was obviously an accomplished stone mason.

A gathering at the South Paris Grand Trunk Railroad Station on Main Street. This brick structure is the only remaining station in Oxford County. It was built between 1888 and 1889 as a replacement for the "Old Brown Depot," which had been in use since the first locomotive arrived here on January 1, 1850.

The Andrews House in the 1860s. This local hotel was previously known as the Atlantic House. It later became a boarding house and then a nursing home. The small white building in the center was the stereoptic photographer's portable shop.

The old Andrews House Livery Stable in Market Square. The driver is Howard Shaw, better known as "Kirby." He was noted throughout Oxford County for his orchestra, called Shaw's Snappy Syncopators.

The old Oxford County Fair Grounds, c. 1910. The Oxford County Fair has long been a major annual autumn event, and it continues each September at the new fair grounds in Oxford on Pottle Road near the Oxford Plaza. The imposing building dominating this photograph is the Exhibition Hall at the old fair ground. This fine T-shaped vernacular post-and-beam structure was built in the 1870s, and it was remodeled, with the visible wing facing Norway added, in the aftermath of a fire in the 1880s. When the Oxford Hills Comprehensive High School was built on the site of the fair grounds on Main Street in 1964, this building was utilized for a number of years for storage by the new School Administrative District #17.

In more recent years, a rather intensive debate transpired over whether or not to demolish the building. Fortunately, this significant historical landmark was spared the fate of so many similar vernacular structures throughout Maine when, in 2003, planners seeking a suitable facility for the new Western Maine University and Community College Center chose to take over and renovate this sturdy 19th century structure rather than erect a completely modern edifice. The rationale was that the vintage building was emblematic of the very purpose for the founding of a higher education facility in the area in partnership with the University of Maine, Central Maine Technical College, and the Norway Career Center: to preserve a sense of community and place. In May of 2004, the Western Maine University and Community College Center was officially opened. Because meticulous attention was given to preserving as much as possible of the original structure (particularly on the second floor), it was given a prestigious Maine Preservation statewide award.

A fine display of automobiles in front of F.B. Fogg Auto Sales, an Essex and Hudson dealer. This business was located near the South Paris Railroad Station on what was originally Pleasant Street (later changed to Main Street). The cars in the center and to the left are 1920/21 Hudsons and the one to the right seems to be a 1919 Moon.

Grace Thayer, who ran the Thayer Funeral Home in South Paris, owned one of the first motor coaches to be used as a funeral hearse in Oxford Hills. Edward Greene took this photograph of her well-polished 1919 Hudson, which had a custom body and wooden wheels, in front of the Deering Memorial Methodist Church in Market Square in August of 1921. Grace later married Frank Fogg, proprietor of Fogg Auto Sales in South Paris.

Henry F. Morton, who was born in Corinna, Maine, and grew up in poverty, would eventually become a dynamic force in the Oxford Hills region. For a time he taught school but was forced to give up this profession because of poor eyesight. It was in 1861, while he was building a sled in the kitchen of his home in Sumner, that he first conceived of the idea of forming a company to build sleds and sleighs. He joined forces with Olban Maxim, a local furniture maker, to form a joint stock company and began operating in Sumner. Later, the operation was transferred to North Paris, then back to Sumner, and around 1870 it was moved to Paris Hill. Here Morton set up a partnership with George B. Crockett and called the company the Paris Hill Manufacturing Company, which over the years made many sleds, sleighs, stepladders, wagons, wheelbarrows, and furniture.

This is the front cover of a fall catalogue put out by the Paris Manufacturing Company in 1885, two years after the company moved down from Paris Hill to South Paris and changed its name to the Paris Manufacturing Company. Although destroyed by fire in 1886, the plant was immediately rebuilt and the company remained a major employer in the area until the late 1980s.

A view of the Paris Manufacturing Company taken around 1910 after it had been rebuilt from the devastating fire of 1886.

An interior view of a portion of the Paris Manufacturing Company where sleds were being made. Standing in the forefront and wearing a suit and hat is Henry F. Morton, the founder of the company. Standing to the far right is George Crockett, the treasurer of the company. George was a half brother of Henry; their wives were sisters.

The Mason Manufacturing Company was built on this site around 1906. As the box car indicates, there was a siding parallel to the main line of the Grand Trunk Railroad. The company originally set up in Pooduck in 1903 to make toys, but in 1906 fire destroyed the building, and the company relocated on a lot which today is next to the Oxford Hills Junior High School. The company merged with the Converse Toy Company (located in Massachusetts) in the 1930s.

An interior view of the Mason Manufacturing Company. The company made toys and children's furniture. The foreman pictured here is Horace Swan.

Those in need of dental work went to Dr. Charles L. Buck, whose office was in South Paris for many years. He also traveled to Bryant's Pond regularly to attend patients. He is shown here attentively working on a patient, *c.* 1910. Notice the brass cuspidor.

A photograph of "The Cave," taken in the late 1880s or '90s by Arthur E. Forbes, who was a printer for the *Oxford Democrat*. "The Cave" was a popular destination for many young people in the Paris area, particularly on Sunday afternoons. Today its exact location is somewhat of a mystery.

The 1912 Paris High School football squad. (Ed Greene photograph)

An Ed Greene photograph of the Paris High School baseball team in 1927. Seated in the center is the school principal, Carlton Fuller, who was a great sports enthusiast, administrator, and teacher. Also shown are from left to right: Stephen Russell '29, 1B; Morris Judd '29, OF; Harry McGinley '27, 1B; Matti Lundell '27, C; John Chandler '27, C; Clarence Bumpus '28, SS; Royce Dean '28, IB; Preston Cummings LF; Edgar Colby '27, LF; Philip Plummer '28, 3B; Hugh Marton '28, RF and SS; Theodore Pratt '27, CF; and Frank Card '30, CF and LF.

An Ed Greene photograph of the 1927/8 Paris High School girls' basketball team. The coach was Bernice Ham, who later became the wife of Reverend Kenneth V. Gray, the pastor of the Congregational Church for many years. The players were, from left to right: (top row) Martha Jordan, Kathyrn Greene, Norine Bryant, Miriam Wheeler, and Julia Bumpus; (bottom row) Clara Nevers, Reta Shaw, Barbara Beede (captain), Rama Judd, Musa Taylor, and Zilpha Doran.

An Ed Greene photograph of the 1925/6 Paris High School boys' basketball team. The coach was Robert L. Jacobs and Clifford J. Dumas was the manager. The players were, from left to right: Matti Lundell, Clarence Bumpus, Henry Plummer, Albion Pratt, Cliff Russell, and Rupert Aldrich.

World War I soldiers in April of 1917, standing at attention in Market Square in front of the old Odd Fellows Hall, which burned in 1921. The large brick building to the right is the Billings Building, built in 1895.

Just as they had in previous wars, the young able-bodied men from the Oxford Hills area answered the call to duty during World War I. Those who remained behind rallied to the cause in any way they could. As the banner indicates, this is a bond rally. Fred Lebaron, a colorful local character, plays the Kaiser, who is represented as "The Beast."

Originally, the imposing house in this Ed Greene photograph was the Shurtleff Estate. Built in the 1880s, it had a well-manicured landscape and was located across from what is now McDonald's in South Paris. At the time of this photograph, the building had become the residence of the Ryerson family. The neo-classical structure at the entrance to the estate served as a shelter for those who were waiting to catch the local trolley going from South Paris to Norway.

Emma Shurtleff was a much beloved and dedicated teacher. She began teaching in the Mountain District in an old brick schoolhouse that was erected sometime between 1816 and 1820, in the shadows of Streaked Mountain. Soon, however, her services were needed at a new school built in the Tubbs District in the 1870s. She finished out her long and successful teaching career in South Paris at the Brick School, built in 1883. The Shurtleff School, named in her honor, was built in 1898 and is currently owned by the V.F.W.

A stereopticon view of the old Bemis Store on Paris Hill around the 1860s. Many of these buildings have either been razed or extensively remodeled.

The center of Paris Hill in the early 1900s. The building on the left was the post office, which was where the *Oxford Democrat* was located until 1895. The building in the background was a local store owned by Newton "Newt" Cummings. In 1924 Newt's store was robbed. The burglar, who was never apprehended, exchanged his wet clothes and shoes for some of Newt's finest apparel. Before he departed, he dined on crackers and cheese, drank soft drinks, and made off with plenty of cigarettes.

Paris Hill was not always the quiet residential area that it is today. Throughout the nineteenth century there were a number of industries operating on the Hill, which served as the Oxford County seat for ninety years.

In the first floor of the building in the foreground, built in 1871, was the Silas P. Maxim Sash Manufacturing Company, which made window sashes, blinds, and doors. Maxim was a builder, manufacturer, and a noted historian of the area. The top section was occupied by the Hathaway & Davis Furniture Company. The gutter running from the roof collected water to be used for a steam mill built in 1870 by John Willis. The citizens of Paris Hill contributed nearly $3,000 to purchase the engine for the steam mill, which generated power to operate the mills.

A stereopticon view looking down Tremont Street at Paris Hill from the belfry of the First Baptist Church, during a winter in the 1870s. The long building at the left end of Tremont Street was the Paris Hill Manufacturing Company.

A horse-drawn snowroller is packing down the snow as it rotates past the First Baptist Church on Paris Hill. By World War I the automobile was rapidly gaining popularity, and snowrollers began to disappear from winter landscapes. The last snowroller reputed to have been used in Maine was in 1927.

The Paris Hill Academy was constructed in 1856 in the Italianate style, and classes began the following year. This group photograph was taken in the late 1890s, shortly before the academy closed its doors in 1901. Today this lovely building is maintained as a community hall.

A view of the old *Oxford Democrat* office (c. 1870s) on Paris Hill, where the local paper was printed for many years until it was moved down to South Paris in 1895. The building with the prominent cupola was the Paris Hill Academy.

A dapperly-dressed George Atwood, a successful entrepreneur from Paris Hill, is taking one of his children for a ride on an opulent summer day. Atwood was a bank president and co-editor with Arthur Forbes of the *Oxford Democrat* from 1874 until just before its merger with the *Norway Democrat* in 1933. The paper is now called the *Advertiser Democrat*.

The Hannibal Hamlin House, c. 1900. Originally known as the Dr. Cyrus Hamlin Farm, Hannibal was born here in 1809. At the time this photograph was taken, the property—with a splendid view of the White Mountains to the west—was owned by the Chase family, who operated a summer boarding house.

A large crowd, numbering close to 3,000 people, gathered in front of the Baptist Church at Paris Hill to hear a speech given by Maine Governor Fernald during the centennial celebration in 1909 of the birth of Hannibal Hamlin, who was Abraham Lincoln's vice-president during his first term. Everything that had wheels was used to transport people from the train station in South Paris up to the Hill for this occasion.

It took fifteen draft horses (owned by G.R. Morton of the Paris Manufacturing Company and some local farmers) to haul this granite megalith from the Hiram Heald field a half mile or so up to Paris Hill in preparation for the 1909 Hannibal Hamlin Memorial Services. As the photograph indicates, the operation ran into difficulties when an axle on the drag broke under the tremendous weight of the boulder.

Fifty years later (on July 27, 1959) this group of dignitaries, headed by US Senator Margaret Chase Smith, gathered in front of the memorial to Hannibal Hamlin at Paris Hill during the Sesquicentennial Celebration of Hamlin's birth. Shown are, from left to right: Harry Lyon, known for his 1928 flight across the Pacific from California to Australia; Julia Carter, a longtime resident of Paris Hill; Senator Smith; an unidentified gentleman; Louise Hamlin, a descendent of the vice-president; and another unidentified gentleman

.A wedding in the 1890s of one of the Colby girls at the Maxim Homestead on Paris Hill. Silas Maxim co-authored (with William B. Lapham) the *History of Paris, Maine from Its Settlement to 1880* (1884). The barn to the right was moved shortly after 1900 down the road a mile or so to the Grant Royal place.

A photograph of the Hubbard family on the steps of the Hubbard House, a prominent hotel on Paris Hill. The hotel was closed in 1938.

Mount Mica, c. 1910. Since 1821, when Elijah Hamlin and Ezekiel Holmes discovered tourmaline here (about two miles east of Paris Hill), few places in the world have produced finer quality gem stones and minerals than western Maine and the Oxford Hills. In 1886 Loren Merrill and his partner, L. Kimball Stone, discovered a deposit of tourmaline at Mount Mica that included the resplendent gem which became the centerpiece of the famous Hamlin Necklace. Tourmaline continues to be found at Mount Mica.

Molybdenite was once mined on Paris Hill here at the Brown Mill, named after Louis Brown, who built and operated it in the early 1900s. The mine closed around 1910, shortly after Brown's death. After the 1914 fire, which destroyed the Paris Farmers Union, the main part of the building shown here was moved down to South Paris and used as a grain mill.

Apple pickers at Ted Daniel's orchard on Paris Hill take a break to pose for this photograph, taken in the early 1940s. The elderly gentleman seated in the front on an apple crate is Grant Royal. Ted Daniels is standing in the rear second from the right. At the turn of the century, the air on Paris Hill was redolent of the efflorescence of apple blossoms, and at one time, apples from the Paris Hill orchards were shipped around the world. Today, the apple industry continues to be a significant part of the economy of the Oxford Hills.

Five
West Paris

First Settled: 1779
Incorporated: September 1957
Population in 1990: 1,514
Area: 65.3 square miles
Principal Settlements: North Paris, West Paris

A view in the late 1920s or early 1930s of West Paris, sandwiched in along the Little Androscoggin Valley. The fields (Brigg's Fields) ascending up to the acropolis-like outcropping called Berry's Ledge have long since been reclaimed by nature. The passing freight train is a reminder that the Grand Trunk Railroad played a major role in the development of West Paris, whose registered voters voted almost unanimously in 1957 to break away from Paris and become a separate town.

A view of Main Street in West Paris in the early 1900s. The three-story building on the far right is the post office. To the left of it is Guy Smith's Store (a millinery store and farmhouse together), Bert Lang's place, and Gammon & Martin's General Store (and residence). Curtis LeGrande's Meat Market and Livery Stable is opposite the post office. The area being excavated was the location of the public scales where loads of hay, milk, wood, and other bulk items could be weighed.

The famous mule train promoting Twenty-Mule Team Borax arrives in West Paris in the early 1920s, after beginning its itinerary in Norway. When it arrived at the point where today Route 117 joins Route 26 to West Paris at Market Square, the team had to be unhooked in order to make the 90-degree turn to head up to West Paris.

Fourth of July parade, *c.* 1914. In this Independence Day parade, the shiny new automobiles rattling down Main Street were ushering in a new period in history. The large store on the left was run by Charles Curtis.

A view of the Maple House, with a 1913 Model-T Ford and a 1915 Buick parked out front. Located on Maple Street in West Paris, the Maple House was owned and operated in the early 1900s by Fanny and Frank Farnum. In 1950 this building was given to the Ring-McKeen American Legion Post, named in honor of the first two soldiers from West Paris to be killed in World War II. It is presently owned by the local Finnish-American Heritage Society.

This factory building at Snow Falls on the Little Androscoggin River (in what is today the town of West Paris) was built as a linen mill in the early 1900s, but linen was never manufactured here. Eventually the building was taken down and rebuilt in West Paris Village as the R.L. Cummings Block.

The linen mill was the last of a chain of industries located at Snow Falls that failed for one reason or another. Over the years floods and fires claimed each one, as well as most of the areas dwellings. Death from accidents and disease decimated the population of the small community. In time the area was abandoned, and only the schoolhouse (operated as a restaurant for many years) and a few scattered hunting cabins near the banks of the river remain.

The tragic history of Snow Falls is linked to the legend of "Mollyockett" (Marie Agathe) and her curse. This itinerant Pequawket Indian woman—highly respected for her knowledge of medicinal cures—is reputed to have placed a curse on the settlement in 1809 when the innkeeper at Snow Falls refused to give her food and shelter on a bitterly cold, stormy, winter night. It is said she continued to Paris Hill, where she was befriended by the parents of Hannibal Hamlin. Their hospitality was rewarded; she is credited with having administered her natural remedies to a very ill young Hannibal, thus aiding in his recovery.

Mann's Mill employees in 1951. Owned by Lewis M. Mann, this mill was set up in 1904. A mainstay in the economy of West Paris for many years, it manufactured wood products such as clothespins and pail handles (which Mann invented). It was forced to close in 1971. Shown are, from left to right: (front row) Arthur Baker, Edgar Hill, Leon Hadley, Jr., Floyd Dean, Chester Hazelton, Chester Morey, and Odel Rich; (second row) Myron Herrick, Steve Maddex, Ronald Ross, Harold Bonney, Roscoe Doughty, Wallace Hazelton, Harold Stevens, Lewis Estes, and Arthur Newell; (third row) Evelyn Barrett, Doris Lawrence, Lucy Ridley, Ida Hadley, Blanche Bean, Beatrice Jackson, Lucy Barrows, Sarah Mann, and Earle Palmer; (back row) Lewis Abbott, Walter Ring, Harlan Stevens, Tom Radcliff, Linwood Buck, Aubrey Cole, Simeon Farr, Earle Treworgy, Walter Inman, and Robert Bean.

This photograph of the corn factory (to the right) and the three-story steam mill (which later became the Paris Manufacturing Company) was taken early in the twentieth century.

In this c. 1913 photograph, Truman Emery and Pete Chase are shown in front of the Maurice Benson House (in the area of the Agnes Gray Elementary School) training two yokes of heifers. The heifers belonged to Frank and Fred Berry, who raised dairy cattle and grew corn for the local corn factory. The boys were hired to hoe the corn at the Berry Farm for free dinners and 75¢ a day. Pete Chase is now ninety-two years old.

The Paris Manufacturing Company and Robinson Mountain form the backdrop for this view of Main Street in West Paris in the early 1900s. The farmers are bringing in their milk and other produce to the station directly opposite Guy Smith's Store (on the left) to be shipped out on the train.

The Stone family reunion prompted this large gathering in 1912 at this farm on Sterns Hill in West Paris. Jacksons, Hammonds, and Stones—all related—gathered each year for a grand reunion. (Ed Greene photograph)

Nina and Edith Bradford and their parents, Mr. and Mrs. James Bradford, on the steps of their farm in Tuell Town, West Paris. The house is now a bed and breakfast run by the Chick family.

Perham's of West Paris as it appeared in 1934. Stanley Perham founded the business around 1919, and today Perham's is owned and operated by the founder's daughter, an eminent gemologist. The splendid display of Maine gems and minerals at Perham's attracts over 100,000 visitors a year from around the world, and is surpassed only by the collections at the Smithsonian Museum and Harvard's Peabody Museum. The mill stones were once used at the local grist mill to grind corn into meal.

Stanley Perham, known as the "Gem Man of Trap Corner," stands in front of his imposing display of tourmaline, rose quartz, beryl, and other gem stones from the Oxford Hills region. Perham began collecting and selling stones from a wheelbarrow at the age of twelve. Four years later, while driving the family cows home from pasture, he discovered feldspar at the site that would eventually become the Perham Quarry.

Mining feldspar at the Perham Quarry, c. 1928. Wherever there is feldspar, there are often gem-bearing minerals. Here, smoky quartz was also found.

Ever since the first recorded discovery of the gem tourmaline in North America, which occurred at Mount Mica near Paris Hill Village, the Oxford Hills and adjacent towns have produced some of the finest gem stones and minerals in the world. As a result of the discovery of significant deposits of feldspar in West Paris in 1923, a mill was constructed in 1925 to process this mineral into material used in the making of spark plugs, electrical insulators, and abrasives used in cleaning powder. Much of the feldspar from West Paris was shipped to England to make glaze for chinaware. The mill continued to operate into the 1970s.

This photograph shows an extensive logging operation in North Paris and Mollyockett Mountain. In the early twentieth century, teams of horses were used to twitch out the logs.

A team of sturdy oxen are methodically pulling a bobsled loaded with logs along a snow-covered road, sometime after 1900. This was a time when logging was a quieter, cleaner operation, much less devastating to the forests. Under good logging conditions a team like this could haul out 4,000 or more feet of logs a day, and up to eleven cords of firewood in a single load on an icy trail.

A view of the West Paris Railroad Station. It was renamed the Bates Station in 1918 after a prominent West Paris family. The feldspar mill is visible in the background.

Sometime before 1918 when the station name changed, this Grand Trunk locomotive jumped the tracks and narrowly missed plowing into the West Paris Station, where passengers were waiting to board.

C.S. "Cabbage" Bacon and his wife Angie are shown here in 1915 tending their general store in West Paris.

Angie and "Cabbage" Bacon standing in front of their general store on Pioneer Street, which was one of the first stores to operate in West Paris. This building was later moved about half a mile down the street and is now a private residence.

The Gammon & Martin's General Store in West Paris in 1936. Martin ran the general store shown here, and Gammon operated a hardware store on the opposite side of the street. Mrs. Lang's Millinery Store is to the right of the general store. The gasoline pump to the left of the three granite hitching posts reflects the passing of an era.

Charles Martin, of Gammon & Martin, and Lyndell Farr, who also taught school, are shown here tending the well-stocked general store in West Paris.

The First Universalist Church casts its reflection into an early spring runoff pond in West Paris Village. For a half century or more prior to the completion of this building on June 19, 1906, Universalist services were held in various buildings in the area. The church features thirteen lovely stained glass windows and a 1,000-pound bell that hangs in the symmetrical tower.

The First Universalist Church choir (c. 1928). Shown are, from left to right: (front row) (?) Kimball, Edwina Mann (Palmer), and Joyce Kimball; (middle row) Elnora Curtis (Blake), Pauline Young (Smith), and Shirley Welch (Rose); (back row) Gertrude Mann (Andrews), Julia Briggs (Morgan), Ruth Stearns, and Phyllis Welch (Young).

A 1930s photograph of the last cast to perform Kate Douglas Wiggin's *The Old Peabody Pew* at the First Universalist Church (now the First Universalist Unitarian Church) in West Paris. The play, which captures the essence of rural Maine communities at the turn of the century, was first written as a novel by Kate Douglas Wiggin in 1904. The setting for the plot is the Tory Hill Meeting House at Lower Buxton Corner, across the Saco River from Salmon Falls in Hollis (where the author lived). She later wrote the play from the novel to raise money for the local community. Because the entire plot takes place within the church, the play became very popular throughout Maine communities for a number of years. It is still performed around Christmas time at the Tory Hill Meeting House where the story originated.

The West Paris High School and Elementary School in the late 1920s. The automobile (probably a mid-1920s Buick) parked in front belonged to Helen Shaw, an itinerant district music teacher from South Paris who began touring local schools in 1917 in a horse and buggy. Starting in 1930, she drove "Henry," her well-known Model-A Ford. Every Wednesday she came to West Paris to teach music to all the students from subprimary through high school, all of whom went to school in this single building.

The 1917 student body at West Paris High School. Shown are, from left to right: (front row) Pete Chase, Rupert Ellingwood, Truman Emery, Chester McAllister, and Vivian Buck; (second row) Pat Stillwell, Oscar Richardson, Ethel Flavin, Ethlyn Gardner, Lula Day, Lyndell Farr, Beatrice Smith, Hazel Cole, and Leland Coffin; (third row) Erlon Whitman, Earle Stevens, Erwin Trask, Ronald Perham, Russell Briggs, Clarence Coffin, Ralph Whitman, and Earle Bane; (fourth row) George Metcalf, Sherman Billings, Edith Stevens, Marjorie Hill, Frank Packard, and Carl Emery; (back row) Mr. Brown (principal and teacher), Carl Bacon, Herbert Hill, Mabel Snow, Diana Pitts, Lydia Ross, Laura Emery, Howard Emery, Ralph McAllister, and Earle Hollis.

The West Paris Class of 1921. Shown are, from left to right: (front row) Lewis Proctor, Ethel (Flavin) Fishgall, Earl Bane, and Hazel Cole; (middle row) Lula (Day) Newell, Leland Coffin, William Littlehale, Lyndell (Churchill) Farr, John Coombs (principal), Rupert Ellingwood, and Beatrice (Smith) Sennett; (back row) Reynold "Pete" Chase, Edward Stillwell, and Chester McAllister.

The first school in West Paris was located on Greenwood Street. This 1889 picture of the student body of West Paris High (or Common) School was taken in approximately the same place that Bill Edmund's blacksmith shop is located today. Sue Thompson was the teacher.

113

The elaborate knee and elbow pads worn by this 1920 West Paris High School basketball squad were designed to protect them from the serious bruises and injuries that might result from falling on the concrete gymnasium floor in the basement of the high school. The players were, from left to right: (front row) Pete Chase, Ronald Perham, and Henry Briggs; (back row) Erwin Trask, Earl Bane, Principal Blazedale, and Russell Briggs.

In 1948 West Paris High School won the Western Maine Championship. The team is shown here posing for a photograph in the new gymnasium built in 1937 by the Works Progress Administration (WPA). Shown are, from left to right: (front row) Clarence "Doodie" Reid, Sydney Perham, Richard Abbott, Gordon Doughty, Owen Morgan, and Lawrence Emery; (middle row) Milton Inman, William Ring, Ardel Hayes, and Stanley Doughty; (back row) Albert Penley, Jr., Joseph Perham, Junior Hadley, Francis Slattery, and Donald Doughty.

The 1921 West Paris High School girls' basketball team. Pictured are, from left to right: (front row) Hazel Cole, Louvie Peabody (Coffin), and Beatrice Davis (Jackson); (back row) Dorothy Wardell, John Coombs (principal), and Leona Marston (Curtis).

A portrait in the early 1900s of Grace Brock when she taught at the Hollow School.

The Little Androscoggin River flows under the bridge leading up High Street in West Paris at the turn of the century. The old grist mill is to the left of the falls, which were known as the Mill Dam. The third floor of the adjacent storage mill is bedecked with buntings and banners welcoming home the boys from West Paris at the end of World War I. The decorations were said to still be hanging when the mill burned in the 1950s.

Six

Woodstock

*First Settled: 1797
Incorporated: February 7, 1815
Population in 1990: 1,194
Area: 48.76 square miles
Principal Settlements: Bryant's Pond, North Woodstock, South Woodstock*

A view of Lake Christopher taken from atop what is now called Summit Hill in Bryant's Pond in the early 1900s. The photograph was probably taken by Mr. Arkett, a photographer who lived in the last house on the right on the hill.

Bryant's Pond Village, looking south toward the old County Road. The County Road, built in 1793 from Paris to Rumford, brought the first year-round settlers to Woodstock—the Bryant brothers from Paris being perhaps the first.

Woodstock was comprised of subsistence farmers and small shifting hamlets until 1851, when the Atlantic and St. Lawrence Railroad (later called the Grand Trunk Railroad) laid tracks through the town. Bryant's Pond Village grew up rapidly around the railroad station and has remained the commercial center of Woodstock.

The building on the right in this photograph was the livery stable. It was later converted to a large garage by Hal Tyler. The first two buildings on the left (opposite the livery stable) comprised the Whitman & Libby Carriage Factory, which manufactured sleighs and carriages during the late 1800s. The building beyond was a blacksmith shop.

The Whitman & Libby Carriage Factory, c. 1880. This beautifully-crafted sleigh was manufactured by the Whitman & Libby Carriage Company. Materials and tools for making carriages and sleighs can be seen in the background.

Looking east on Main Street in Bryant's Pond, c. 1870. The building on the right was originally the Jewell Store, which was built in 1852 along with much of the village. There was such a demand for a store here that even before the building was completed, the owner transacted business from several boards stretched across carpenter horses that served as improvised counters. On the left is the Ezra Stephens Store, and the following building is the warehouse which housed the Ezra Stephens' Circus paraphernalia. The fourth building on the left (with the second floor porch) is the Chase Store, which housed a drug store and a print shop—both of which were operated by A.M. Chase, a justice of the peace, notary public, surveyor, printer, druggist, and local band conductor.

A view of Lake Christopher from Arkett's Hill (Summit Hill). The Universalist Church is visible in the distance to the left. The Bryant's Pond Railroad Station, including the freight shed, can be seen here at the foot of the hill. The freight shed is still extant and is currently the main structure of the local village store on Main Street. The sheep pens seen here adjoining the freight shed are a reminder that raising sheep was an important agricultural activity in the area. The surrounding hills, now cloaked with forests, were sheep pastures over a century ago.

The water tower shown here (at the rear of the station) is the reason Bryant's Pond exists. Railroaders claim that the grade leading up to Bryant's Pond from the south is one of the steepest east of the Rockies. Consequently, locomotives consumed enormous quantities of water by the time they reached this spot, which is why Bryant's Pond became a "tank town" (in railroad jargon). Since trains stopped frequently to take on water, a telegraph office was considered necessary. As a result of all this, Bryant's Pond grew up around the station, and the area became the base for a stage coach and freight line to Rumford Falls and Andover.

The building just above and to the left of the railroad station is one of two buildings in the area that predates Bryant's Pond Village. It was a farm prior to 1852.

A scene of Bryant's Pond Village in the late 1880s. The house to the far left on the hill was the Arkett residence (later the Joseph Farnham residence), located on Summit Street. Coming down the hill, the large, white, two-story building was the original Woodstock High School before a new school was constructed.

Main Street of Bryant's Pond, facing north, c. 1930. The first structure on the right was Cole's Hardware Store (now Mollockett Antiques). The second building was Chase's Drug Store and Chase's Print Shop (now an art shop), followed by Davis' Confectionery Store—which also sold gasoline (only the pumps are visible). The small square structure was the spring house. The large house on the left was the Dudley residence and beyond is the Dudley Store. All of the buildings visible were built in the 1850s.

121

The firm of H. Alton Bacon, shown here around 1931, was an impressive operation for a community as small as Bryant's Pond. It did its own mill work, making moldings, sashes, blinds, doors, and finishes. The company had carpenters building houses, many of which were quite sophisticated, and also employed its own plumbers and electricians, who took in apprentices and trained them. There are still residents in town today who received their training from H. Alton Bacon. The above photograph shows: (beside the company truck) George Forbes, Clarence Wing, Clyde Dunham, and Lesslie Bryant; (upper level) Leslie and Benjamin Abbott.

In front of the Grange Hall is H. Alton Bacon's 1914 Model-T Ford with gas lights. The truck is loaded with wooden shingles to be delivered to a customer.

The W.G. Morton Home Furnishing Store was located down Main Street near the Masonic Hall. An advertisement for the store stated: "Goods sold at city prices for cash or installments. Sales to the amount of $10.00 or more delivered within 20 miles free."

The main building in South Woodstock of I.W. Andrews, where caskets were made. I.W. Andrews (standing to the left) is shown here with six of his casket makers and his assistant in the undertaking business (on the far right), c. 1920.

A parade in the town of Woodstock around the turn of the century. The building on the right is the Glenn Mountain House, which was destroyed by fire in 1908. The fire also wiped out Stephens Store and a warehouse which housed the Ezra Stephens' Circus paraphernalia. Ezra Stephens was heralded by the late Maine author Holman Day as being "The P.T. Barnum of Maine."

The Bryant's Pond Silver Cornet Band is bedecked for a local performance around 1900.

The Libby Store and the Dudley Opera House decorated for the Fourth of July. The Opera House, built in 1901, provided local residents and visitors with a variety of entertainment until it was destroyed by fire in the late 1920s. Basketball games were played here, early motion pictures were shown by an itinerant operator who came around once a week, and traveling players performed plays using local citizens in minor roles. Carl Dudley, the owner of the Opera House, also ran a store and owned the Electric Power Company, the Bryant's Pond Telephone Company, and the nucleus of the water company.

The Bacon Family Orchestra played for local dances from at least the 1880s until around 1924. Shown are, from left to right: Walter, Ralph (the last family survivor), Myrtle, Herbert (who conducted and did the arrangements), and H. Alton. The orchestra disbanded around 1924 when Myrtle moved to Massachusetts to teach music.

125

The Quimby Perham Farm on Black Brook Road in Woodstock, c. 1907. This magnificent set of farm buildings is a reminder that agriculture was at one time the backbone of the Oxford Hills area.

Taking time out from a busy summer day's work for a group photograph at the Cushman Farm, c. 1900. Despite the adversities of farming in the area, these well-maintained buildings indicate that the Cushman Farm prospered and the family took great pride in their land and their farm.

In the 1930s wood was still the major source of fuel, and many of the farmers in Woodstock and throughout the rural Oxford Hills still worked with oxen, such as those seen here on the Cushman Farm. Local farmers added to their incomes by cutting and selling cordwood, pulp wood, and logs during the winter months when the land remained locked in a frozen hiatus.

Two gentlemen on an outing with their bicycles on a dusty country road in front of the Cushman farmhouse.

Local cows headed home. For over a century and a half it was a common practice for almost every family in the Oxford Hills area to keep a cow or two. A reliable local teenager was usually hired to collect the cows every morning during the late spring and summer months and herd them to a community pasture. The tradition seemed to linger longer in Bryant's Pond than anywhere else in the region. Howard McKillop, who still resides in Bryant's Pond, was the last cowherd in the area and perhaps all of Maine. In this 1930s photograph, the local cows are being driven down from the pasture on Merrifield Hill, past what is now the Baptist Parsonage (on the opposite side of the road) and what was then Myrtle Bacon's Tea Room (foreground).